Tabletop Photography

Cyrill Harnischmacher is a photographer and designer who lives and works in southern Germany. His first book, *lowbudgetshooting* won him the prestigious Fotobuch-award of the German Booksellers Association in 2005. Cyrill is a studio photographer by profession and a nature and infrared photographer by passion.

Cyrill has authored four beautiful, accessible, and successful books published by Rocky Nook.

Earlier titles include *Low Budget Shooting, Closeup Shooting, Digital Infrared Photography*, and *The Wild Side of Photography*.

Cyrill Harnischmacher

Tabletop
Photography

Using Compact Flashes and Low-Cost Tricks to Create
Professional-Looking Studio Shots

rockynook

Cyrill Harnischmacher (www.lowbudgetshooting.de)

Editor: Jocelyn Howell
Copyeditor: Jeanne Hansen
Layout and Type: Cyrill Harnischmacher
Cover Design: Cyrill Harnischmacher
Printer: Everbest Printing Co. Ltd through Four Colour Print Group, Louisville, Kentucky
Printed in China

ISBN 978-1-937538-04-0

1st Edition 2012
© 2012 Cyrill Harnischmacher

Rocky Nook Inc.
802 East Cota St., 3rd Floor
Santa Barbara, CA 93103

www.rockynook.com

Title of the German original: Tabletop-Fotografie mit Kompaktblitzgeräten
Copyright © 2011 by Cyrill Harnischmacher, Reutlingen, Germany.
(ISBN: 978-3981229318)

Library of Congress Cataloging-in-Publication Data

Harnischmacher, Cyrill.
 [Tabletop-Fotografie mit Kompaktblitzgeräten. English]
 Tabletop photography : using compact flashes and low-cost tricks to create professional-looking studio shots / by Cyrill Harnischmacher.
 -- 1st ed.
 p. cm.
 ISBN 978-1-937538-04-0 (hardbound : alk. paper)
 1. Photography, Table-top. 2. Electronic flash photography. I. Title.
 TR683.5.H3713 2012
 778.7'2--dc23
 2012005042

Distributed by O'Reilly Media
1005 Gravenstein Highway North
Sebastopol, CA 95472

Many special thanks to Urte, Tabea, Jona, and everyone who helped with the creation of this book.

Contents

Preface

The tabletop studio offers photographers the chance to hone their craft and develop photographic projects both day and night, regardless of weather and lighting conditions. Lights, backgrounds, props—in short, everything that defines an image—are under the control of the photographer, who can stage scenes that range from objective to realistic to elaborate.

Tabletop photography actually belongs to the domain of studio photography, which usually involves expensive equipment, large studio flash systems, and sophisticated accessories. But it doesn't have to be that way. With a few shoe-mount flash units, a touch of crafty spirit, and a measure of imagination, you can create stunning results with modest means. Whether you intend to take pictures for product catalogs, online auctions, foundation exposures for composite images, or you just want to capture your culinary masterpiece in a fitting scene, shoe-mount flashes can take you far—quite far, actually. These flash units, sometimes called flashguns, are small, light, and battery operated, so you don't need to worry about extension cords and power outlets.

More important than anything, however, is the fact that these types of flashes are widespread. There is hardly a photographer anywhere who doesn't already have one or more of them. In short, you won't have to invest in any new technology, and you can get started right away.

This book is intended primarily for amateurs who are making their first foray into tabletop photography and who don't already own studio lighting systems.

Cyrill Harnischmacher

The Basics

A Taste of Theory to Get Started

There are only a few variables that influence the exposure of an image. The focal length of the lens determines the perspective, the aperture defines the depth of field, the focus determines what will appear sharp in an image, and the lighting affects the mood of an image. Since working in a studio means you're in the fortunate position of being able to control all these variables, there are countless variations for exposing a single subject.

Tools of Design: Sharpness and Blur

In addition to determining the depth of field, the aperture also defines the degree of blur. Both sharpness and blur have an influence on the effect of an image; they can create an objective impression, on one hand, or a romantic impression, on the other. Since we have control of all the elements in a table-top photo shoot, we are not limited to affecting the sharpness and blur by adjusting the aperture. We can also adjust the composition of the image or the relative distances among each of the elements of the picture. This means, for example, that we can intentionally place an element of an image beyond the depth of field to give the impression of a greater space or to separate the elements of the picture more clearly.

The distance of the main subject from the background of an image and the positioning of the lines of focus in an exposure are of extreme significance. They help you develop the sense of space in your images or, in other words, guide viewers to pay attention to important details.

Designing with Focal Length

The selection of the focal length also influences the effect of an exposure. A wide-angle lens causes objects in the foreground to appear larger and also allows you to capture a larger background. In contrast, a telephoto lens compresses an image to make

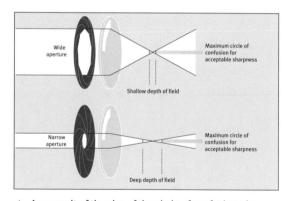

▲ *As a result of the size of the circle of confusion, the wider the aperture, the smaller the depth of field in which the subject will appear acceptably sharp.*

▲ *Aperture as a tool of design. A wide aperture of f/4 with shallow focus and lots of blur.*

▲ *A narrow aperture of f/22 with a large depth of field.*

▲ *Focal length as a tool of design. With a wide-angle 12 mm lens, the exposure appears distorted but dynamic.*

▲ *With a standard 50 mm lens, the exposure has a more objective look, similar to the eye's natural perception.*

it appear more compact and also depicts less background in relation to the main subject of the image. A standard lens, which is often a macro lens for tabletop photography, portrays objects in the same manner that the human eye perceives them and is accordingly useful for product shots in which you want an objective perspective.

Light

A photographer's most important tool of design is light or, more specifically, the ability to alter the quality of light by shaping it. Shaping light in this sense has two meanings: first, photographers can shape the light itself to be flat, pointed, hard, soft, scattered, and so on; second, light shapers allow photographers to stylize their subjects by modulating the lighting to match their photographic ideas. This is the exact process—which we call photography—that allows us to create two-dimensional images of objects based entirely on the interplay of light and shadow.

Designing with a Purpose

Last but not least, a photographer's creative instinct and an effective composition are essential factors for creating a successful picture. These include selecting the right background, including appropriate props, and establishing a visual style that corresponds to the subject. You must remain objective when creating product shots and set a dramatic scene when it's appropriate to tell an emotional story with your picture.

If you're working professionally, the intended purpose of a photograph should always be the primary influence for your visual design. The elaborate staging of a screw, featuring multicolored lighting and a tight focus, might function very well for the cover of a product catalog, but the same picture wouldn't be appropriate to convey objective information. For this purpose it would be better to create a clear product shot depicting all of the details of the screw in a neutral manner.

Naturally, this also applies to the world of amateur photography. Whether you are creating a photographic archive of a collection, or capturing an image to use on an invitation, or taking pictures for an Internet auction, you should always consider the context in which the photo will be used and the effect you want the image to have on the person who views it.

Knowing Technology by Heart

Using the necessary technology properly requires both the knowledge of how it works and a certain amount of accumulated experience from regular use.

The combination of this knowledge and experience will help you use your equipment purposefully and intuitively.

It is good practice, therefore, to set up a few assignments for yourself from time to time and practice creating several photographic variations of the same subject. Your subject could be an everyday object staged in a variety of differing lighting conditions, or it could be a broader theme, such as depictions of glass or transparent objects, or even abstract images of aroma, coolness, softness, or something similar. Compare the results of the pictures you create and discover which techniques achieved the best results.

A Conceptual Approach

It's not unusual for the preparations for complex photo shoots to take several hours. For this reason, it's important to work out a concept for the exposure in advance. Start by mocking up a few sketches of your subject and planning the setup for your lighting. When you're working with a moving object that you need to capture at a specific moment, you should also plan the timing for the shoot. One very useful tool for this is the Photoshop file LightingSetup.psd, which you can download from www.kevinkertz.com for personal (noncommercial) use. This file contains a variety of tools to diagram your shoot, including light shapers, backgrounds, cameras, and notes that can be individually placed.

Before you get started with your shoot, all of the required tools and materials should be handy, your batteries should be fully charged, and your work space should be clean and prepped so that in the heat of the moment everything will run as smoothly as possible.

Finally, always ask yourself the following questions before starting your shoot:

- Will my plan achieve the desired result?
- Do the background and props serve the desired message?
- Are the subject and the background properly illuminated?
- Will the viewer's gaze be attracted to the important details of the image?
- Does the selected focal length, perspective, and depth of field suit the subject?
- Is the focus on the optimal spot?

Can you answer yes to all of these questions? Then get ready to fire away.

Technology

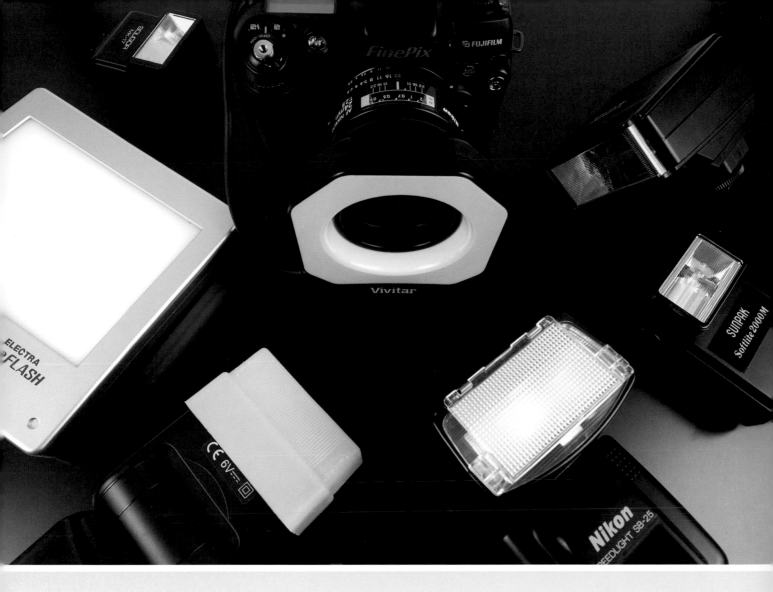

The small size of compact or system flash units makes them ideal for tabletop photography. Their flash output is more than adequate because this type of photography doesn't require large areas to be illuminated. They are simple to operate and can even be used in places without a power outlet. The availability of new and used flash units is almost overwhelmingly large. If you are considering purchasing or trying out a flash for tabletop photography, you may want to consider the following issues.

At a minimum, your tabletop flash unit should include the following:

- Manual control in as many levels of output as possible
- Sync cable connection (or the option to use an adapter)

Examples of other useful functions are as follows:

- Integrated infrared sensor
- Wireless control
- Fastest possible flash recovery

As a rule, most higher-end units from major camera and flash manufacturers offer all of these functions. Although it's theoretically possible to use any flash, it can be prudent to limit yourself to one manufacturer. One benefit of doing this is you won't have to switch back and forth between different methods of operation. Additionally, all of your equipment will likely be compatible and interchangeable.

You can find good deals on a number of quality used flashes. The SB 24, SB 25, and SB 26 from Nikon are very popular used flash units because they offer most of the recommended functions previously described. The SB 26 even features an integrated infrared sensor so it can be discharged wirelessly as a slave flash with an infrared shutter release. Small flash units with smaller guide numbers are fairly inexpensive on the Internet and are great for providing additional effect lighting.

Manual or TTL?

Modern flash units are becoming increasingly advanced and more closely integrated into camera systems. What used to be simple shoe-mount flashes have developed into multifunctional units that coordinate actively with the camera, and sometimes with other flash systems, to allow photographers to comfortably create balanced exposures. In the realm of tabletop photography, however, these well-intentioned advancements are more or less superfluous. With this type of photography, it's more important to have complete control over the light. Mixing flash

sources is undesirable, so you should turn off any automatic flash settings on your camera and flash units and become an expert at using the manual modes of operation. This is easier than you might expect.

The Light of Shoe-Mount Flashes

The essential difference that makes studio flash equipment better, aside from the difference in power output, is that shoe-mount flashes lack a modeling light. The purpose of a modeling light is to allow photographers to develop a sense of the light distribution before taking an exposure. It also provides advantages when you want to position accent lights exactly. Using shoe-mount flash units means you won't be able to create test exposures to examine on a display. Thanks to digital photography, though, this isn't a huge problem anymore. And since you generally will create test exposures to control the subject composition, for example, the costs are also kept in check.

If you are working with large soft boxes, you can improvise a modeling lamp by placing an LED flashlight in the box. This light doesn't offer control proportional to the power of a flash unit, but it does deliver a first look at the distribution of light and shadow. This will surely change in the near future as the power output of LEDs continues to rise. From a technical standpoint, the integration of an LED modeling light into a flash unit doesn't pose any problems. Manufacturers should see this as a valuable competitive advantage.

Simple product shots can look great without too much effort. The indirect key light comes from the left, bounced off a white wall, and the indirect fill light is bounced off the ceiling.

As basic equipment for tabletop photography, a standard zoom of around 24 to 100 mm is more than adequate. This focal length range will allow you to handle most situations that come up in the studio without any problems. High-aperture varieties generally have better imaging performance, and they also have the advantage of allowing photographers to isolate their subject from the background by using a wide aperture. This can also be accomplished by adjusting the distance between the subject and the background, of course, but often there is not enough room to achieve the same effect.

Today's advanced image stabilizers are largely unnecessary in the studio because, as a rule, you shoot with a tripod and flash. Most studios are too small for focal lengths longer than 100 mm. This isn't the case, however, for wide-angle lenses. Those with a small minimum focusing distance are especially useful in creating expressive pictures. You do have to be careful, however, to not include half the studio and the lighting in your image.

In general, it's advisable to use a lens hood, no matter what kind of lens you're using. It will prevent stray light, such as light from flash units placed near the camera, from adversely influencing the exposure.

Most standard zooms also feature a macro setting, which allows you to capture closeup and macro images, to a certain extent. A macro lens with a reproduction ratio of 1:2, or better yet 1:1, lends itself for use not only when you want to closely approach your subject, but also when it's important to get images that have the highest possible clarity and the least possible distortion, as with technical subjects or reprography.

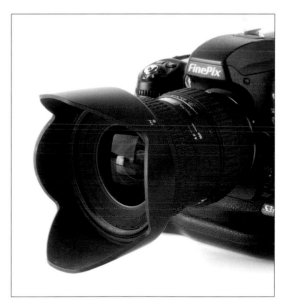

▲ Be sure to use a lens hood to avoid stray light, *especially with wide-angle lenses.*

Flash Control

How does the correct signal from the camera travel to the flash unit? There are many different methods, and each has advantages and disadvantages. One option is to send the signal directly through a cable or wirelessly with infrared or radio technology. In these cases, the power output on the flash and the exposure settings on the camera (aperture and shutter speed) must be set manually. Another option is to use TTL technology, which, in simple terms, enables the camera's exposure meter to send a signal to the flash unit and disable it, if the picture is properly exposed. As a rule, these automatic TTL programs deliver excellent results for normal photography. However, since tabletop photographers work with multiple flash units and reflectors, diffusers, color gels (or filters), mirrors, and so on, TTL systems can misinterpret the photographer's desired result and improperly expose the shot. These problems can be remedied by adjusting the camera or the flash units, but this results in a manual control of sorts, which is much more complicated than controlling all of the devices manually in the first place. It's just not practical to use TTL technology when working with studio flash systems. In the studio, it's best to control everything manually. This allows photographers to master the situation and regulate all of the parameters necessary for realizing their vision for the shoot.

Sync Cable

This solution is far and away the most cost-effective choice. To choose this option, however, your camera and flash unit need to have compatible sync cable ports. The cable simply transmits the trigger signal, so all of the settings on the camera and the flash must be set manually. If there aren't compatible ports on your devices, you may be able to purchase an adapter that will get the job done. Several flash units can be used with a flash sync cable splitter, which has a very reliable trigger.

Cables do have one large disadvantage: you can trip over them. Especially in the tight quarters of a studio, it's possible to yank the camera and knock it and the tripod over if you get your foot caught in the cable.

TTL Cable

This connection method allows the complete TTL signal to transmit to the connected flash. TTL cables are often relatively expensive and are rarely available in extended lengths. Their advantage is the same as a normal sync cable: they are trustworthy and trigger reliably. TTL cables are a good choice for photographers who work with flash units and light shapers affixed to a flash bracket on the side of their camera.

Wireless Infrared

Using wireless infrared technology to release your flash units will provide you with greater freedom of movement. A signal is transmitted from an infrared trigger placed in the camera's shoe mount to a sensor on the flash unit. You should ideally position the infrared trigger upward because the small red light can be reflected on objects in the scene that have shiny surfaces. Wireless infrared also requires that you manually define all power settings on the flash. For flashes that don't feature an integrated infrared sensor, you can purchase an adapter from a store that sells photography accessories.

Infrared triggers generally rely on visual contact with the flash, which is more or less a given in the world of tabletop photography. They are affordable, but they are increasingly being replaced by radio transmitters.

Wireless Radio

This system also uses a transmitter positioned in the hot-shoe mount of the camera that sends a signal to a receiver on the flash; this method, however, uses a radio signal. Radio signals have the advantage of functioning on days with bright sunlight and traveling through walls. These benefits aren't always relevant in tabletop photography, but if you work outside frequently or shoot in large buildings you will find radio communication systems exceptionally useful. Most devices offer the option of functioning in two or more channels.

Wireless TTL Control

The largest advantage of wireless TTL control is that it allows multiple flash units to be entirely regulated by the camera or master device. This means you'll have a substantially easier task in many cases. Other features, such as high-speed synchronization, transferring color temperature information, and using multiple channels and groups, are rarely required for tabletop photography, but they nevertheless make the costs of this option higher.

▲ *When using a colored light source under low light conditions, it makes sense to omit the wireless TTL Control and set the camera and flash unit manually.*

▲ Left: Camera sync cable port. Middle: Attachable sync cable connector for a camera's hot-shoe mount. Right: Sync cable connection (lower port) on a flash unit.

▲ Left: TTL cable attached to a camera. Middle: TTL cable with a splitter for auxiliary flash units. Right: Wireless TTL control.

▲ *Left: Infrared trigger affixed to the camera. Middle: Plug-in slave flash sensor for the shoe mount.*
Right: Plug-in slave flash sensor that fits in the sync cable port.

▲ *Left: Radio receiver for the sync cable connector. Middle: Radio trigger attached to the camera.*
Right: Shoe-mount radio receiver.

Camera Control

Looking through the viewfinder and subsequently pressing the shutter-release button is the classic way of controlling a camera, but this method comes with a few drawbacks. As a rule, photographers working in a studio use a tripod, but accidentally touching the tripod can lead to an unwanted shift in the camera's perspective, or, if you're working with a tight focus, it can cause the important details in the image to no longer be in focus.

Avoiding Camera Shake

Wire, cable, and infrared remote release systems help photographers take pictures without having to touch the camera at all, and they are basic equipment for any studio. These systems are also practical in other situations, such as when it is difficult to reach the camera because it is placed directly above the subject, or if there is any potential that the photographer's reflection will show up in the image, or if the photographer's body will interfere with the lighting.

Remote shutter-release options exist in a variety of styles and price categories. The most inexpensive option is a simple cable that enables you to release the shutter remotely. Somewhat more expensive solutions use infrared or radio communications.

When you purchase a remote control system, make sure it allows you to keep the shutter open so you can take shots with long exposures in B mode.

Remote Controls with Displays

You can more comfortably control the arrangement of your subject by using a remote control that also has a monitor. Manufacturers use different approaches to create systems like this. Some models require a camera with a live view, and others use a small camera to capture the image in the viewfinder and transmit it via a cable to the display on the remote control. This means you no longer have to look through the camera's viewfinder to examine the composition every time you make an adjustment to your subject. Instead you can comfortably make changes and check your work directly from the worktable.

You can have even more freedom with a wireless remote and display, such as the Gigtube Wireless from Aputure, which allows you to take the image in your

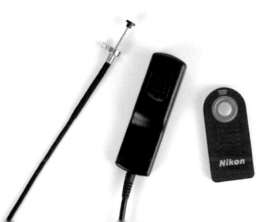

To avoid camera shake or an unintentional shift in the camera's angle of view when pressing the shutter-release button, use a wire, cable, or infrared remote-control trigger; alternatively, you can use the camera's built-in self-timer.

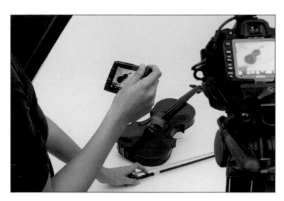

▲ With a radio-controlled remote shutter release, the viewfinder becomes portable, which is especially helpful for arranging your subject.

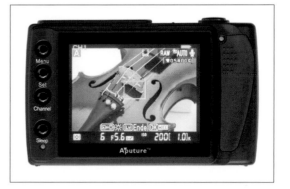

▲ On the auxiliary display, all of the relevant settings of the camera are visible, such as aperture, shutter speed, white balance, and so on. You can find more information about the Gigtube Wireless at www.aputure.com/en/.

camera's viewfinder into another room to discuss the shot with your customers or colleagues. It can also help you with shoots involving unusual camera positions. Anyone who has worked with a camera positioned just below the studio ceiling will immediately recognize the benefit of this option. With multiple transmitters and cameras you can switch between various camera positions by changing channels.

The transmitter works on four different channels and has a range of up to 100 m (328.1 ft).

Controlling with a Computer

If you require yet more control over your shot—for example, to adjust the focus or the colors of the exposure—don't overlook the option of controlling your camera with a computer. With the assistance of corresponding exposure software you can completely control your camera while sitting at the computer monitor. Normally studio photographers opt for a laptop, but a stationary computer works just as well, especially when it is linked to a calibrated monitor.

Almost every major manufacturer produces an exposure control software application. The range of functions varies from program to program, ranging from simply releasing the shutter to more complex operations, such as controlling the shutter speed, aperture, white balance, and brightness correction as well as setting up a series of shots or bracketing. If you can connect your camera to a wireless local area network with an adapter, you can even do away with the cable between the camera and the computer that so often causes stumbles. Since using a computer to control a photo shoot requires a bit more technical and financial investment, it makes the most sense to go this route for very complex or large product photo shoots.

Many camera and software manufacturers offer applications and technology that allows you to control your camera remotely with a computer. The functionality of these programs ranges from simply releasing the shutter from your computer to controlling all of the exposure parameters.
From top to bottom:
Apple Aperture,
Adobe Lightroom,
Canon EOS 5D.
Screenshots by Jürgen Gulbins.

Right image: Fuji Studio Utility.

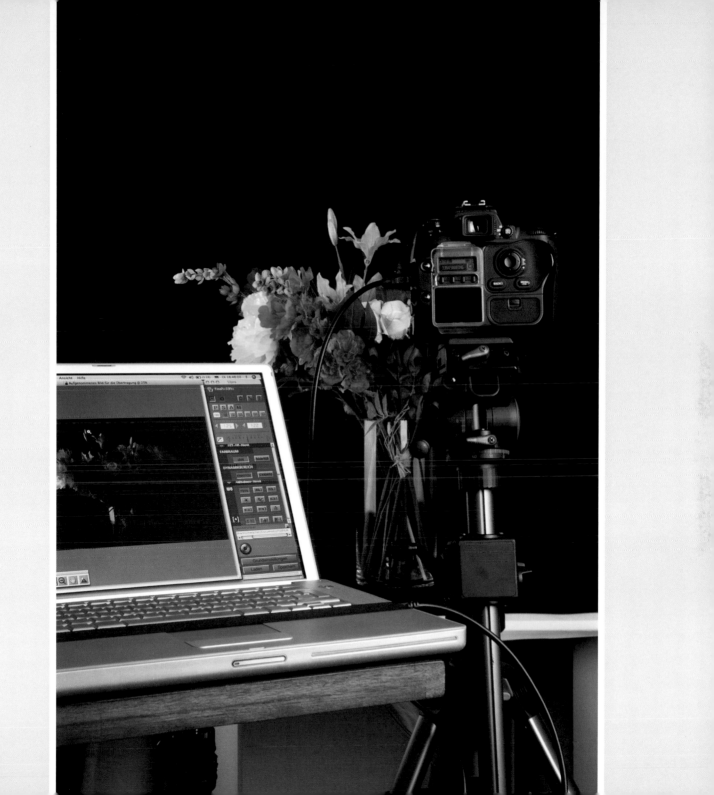

Light

Professional Light-Shaping Tools for Shoe-Mount Flashes

For a long time, light-shaping tools were designed to be used only with studio flash systems. But for some time now, soft boxes, beauty dishes, barn doors, and snoots have been available for shoe-mount flash units, which means there's nothing standing in the way of taking professional images on a tabletop studio. The flash2softbox adapter melds a camera's flash and light-shaping tools into one. These adapters are available for conventional flash units and hammerhead flashguns from a variety of manufacturers. The flash2softbox system is sold through www.flash2softbox.com.

▲ *Light-shaping tools are fastened to the ring of the adapter with set screws.*

The flash2softbox adapter connects shoe-mount flashes to light-shaping tools.

Soft Boxes and Strip Lights

The classic tool for shaping light in studio photography is a soft box. This tool allows you to handle most situations that require soft light. Soft boxes usually have a rectangular or square front that makes it possible to reflect appealing light onto surfaces. Smaller soft boxes are particularly useful for macro exposures and for light accents with larger compositions. With sizes from 50 x 70 cm (19.7 x 27.6 in) and larger, you can also cover a portion of the front with black cardboard to improvise a strip light. Octagonal soft boxes are popular with portrait and beauty photography because they create an attractive highlight in models' eyes. Photographers use strip lights, which are long, narrow soft boxes, to highlight edges with reflected light. Many soft boxes also have an additional internal diffuser that evens out the light within the box, but it can be removed to reduce the loss of light. Several manufacturers offer optional honeycomb fabric filters that prevent stray light from the illuminated background from entering the lens.

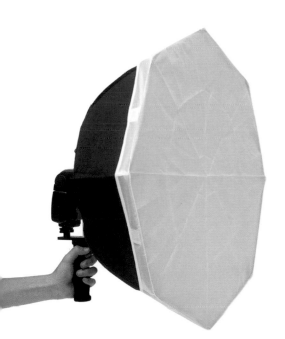

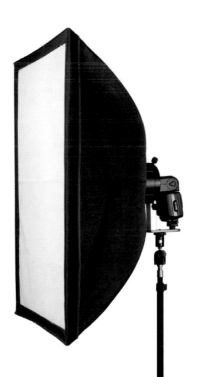

A rectangular soft box is standard equipment in any studio; octagonal soft boxes are commonly used in portrait and fashion photography.

Special Light-Shaping Tools

Special light calls for special light-shaping tools. If you want to get away from the soft, uniform light of soft boxes and umbrella-style reflectors, you might consider using a beauty dish. The light it emits is less soft than that of a soft box, and the shadows it creates are perceptibly darker and more intense. Using a beauty dish in combination with a honeycomb filter creates yet more focused light with sharper shadow edges. Honeycomb filters also have the added benefit of preventing stray light from illuminating the backdrop, which is especially critical for shoots featuring sidelight and a black backdrop.

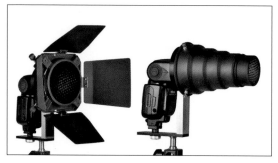

▲ *Photographers are fond of using barn doors, honeycomb filters (left), and snoots (right) to create effect lighting. Photo: Claudia Gitter.*

Snoots and barn doors focus light into very narrow cones and are frequently used with color gels to create effect lighting. Thanks to the ability to fine-tune the output of most flash units to 1/128 of the total output, and sometimes even less, you can create very subtle light accents that wouldn't be possible with a large studio flash system. Also, because of their small size, they are ideal for placing behind a part of the subject. Photographers can also use snoots and barn doors in combination with honeycomb filters to create even narrower cones of light.

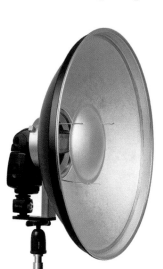

Beauty dishes create directed light with dark but soft shadows.

Umbrella Reflectors and Umbrella Soft Boxes

Umbrella-style reflectors and soft boxes are practical and portable tools for lighting. They're easy to open, and you can prop them up on stands that are specifically designed for the purpose. Umbrella lighting tools are available in a number of diameters and varieties. Some have gold, silver, or white reflective surfaces; others function as diffusers through which light is emitted; and yet others work similarly to soft boxes with an additional diffuser. Using umbrellas makes sense in any situation where only soft light is available. They're not ideal for objects with shiny surfaces, however; in contrast to soft boxes, they create harsh light on reflective surfaces. An umbrella with a gold lining engenders a warm light reminiscent of late afternoon sunlight. Umbrellas lined with silver create a cool light that lends itself to technical compositions. Diffuser umbrellas function similarly to soft boxes and create very soft shadows. You can easily equip umbrella reflectors with more than one flash unit. (The last chapter of this book contains assembly instructions for a fixture to accomplish this.) Photographers often use this method in outdoor shoots. It's worth mentioning that the protruding shaft from the umbrella can be bothersome in the frequently cramped quarters of a tabletop studio.

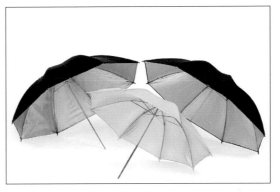

▲ *Silver, gold, and white coatings create different colors of light. Photo: Claudia Gitter.*

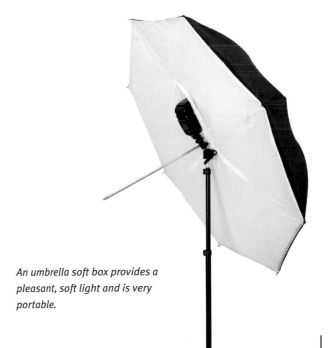

An umbrella soft box provides a pleasant, soft light and is very portable.

Reflectors and Diffusers

Reflectors

Reflectors are indispensable and definitely belong in every photography studio's standard equipment. The easiest way to come by reflectors is to pick up sheets of polystyrene from your local hardware store. They're light, won't bend, and are unbeatably cheap. They also have a textured surface that reflects light very evenly. When used with a shoe-mount flash, they noticeably increase the illuminated area, creating soft light and soft shadows. As an alternative you can also use white cardboard, which is easier to trim. This means you can make narrow strips in the reflectors and allow light to accent the contour lines of your subject without much difficulty. Presentation boards used in graphic design are especially useful because the cardboard is affixed to a lightweight foam panel that makes it stiffer and less likely to twist. One other tip: pick up some shelf brackets from a hardware store to use as a base for your reflectors and to prevent them from falling over onto the subject of your photo shoot.

You can create special effects with your reflectors by coating them with silver or gold foil or painting them different colors. Water-soluble acrylic paint, often used by craft painters, is a good choice for polystyrene sheets, cardboard, and several other materials. It's matte after it dries, it's waterproof, and it's easy

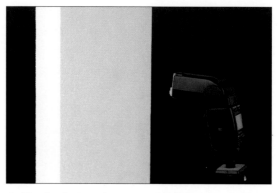

▲ *The simplest way to create soft light is to bounce the light from a flash off a reflector; here a panel of white polystyrene is used.*

to work with. Polystyrene sheets might be dissolved by the solvents contained in enamel paints.

The opposite of a reflector is a shade, which is a black matte surface that keeps unwanted stray light from illuminating the subject. A shade can also be set up to intensify shadows, for example, or to accentuate dark edges in glass surfaces.

Diffusers

Diffusers are made of transparent material. Their purpose is to scatter light, thereby making it softer. It's important that the material used to make a diffuser is a neutral color, otherwise you'll end up

▲ *Shelf brackets from the hardware store lend them-selves perfectly for holding up reflectors.*

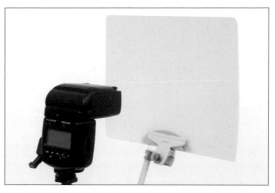

▲ *A transparent folder masquerading as a diffuser.*

with an unwanted color cast in your image. You can achieve especially good results with special diffusion foil available from stores that sell photography accessories. With a little bit of craftsmanship you can use this material to create diffusers of all shapes and sizes by stretching it over frames made from strips of wood. You can also use a number of everyday materials, such as translucent folders, artificial parchment, or a piece of frosted glass or Plexiglas, to function as a diffuser.

To set up reflectors, shades, and diffusers, you'll need the aforementioned shelf brackets in addition to a clamp light with a gooseneck or a desk lamp that's had its lampshade replaced with a holding clamp. Special fork attachments that fasten to most light stands are available for polystyrene sheets so you can simply pierce them to hold them in place. You'll find instructions for doing this in the last chapter of this book. In a pinch you can also hang a reflector from the ceiling with a couple of laces.

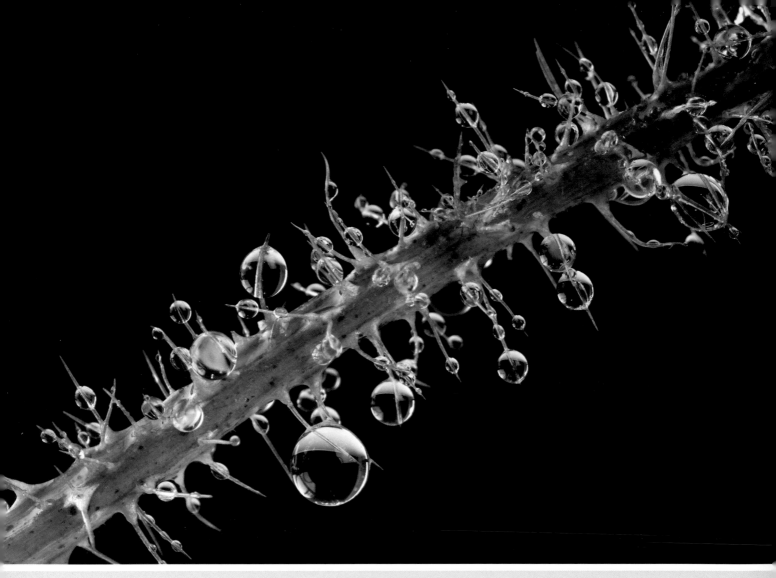

▲ *The stem of a thistle sprayed with water. The mirrored images of the white reflectors in the water droplets effectively emphasize the spherical shape of the drops.*

▲ *The ample and uniform light of soft boxes serves a number of purposes in the studio. Among them is creating expressive reflections in glossy surfaces to emphasize the shape of an object.*

A Comparison of Light-Shaping Tools

On the following pages you will find examples of how the various light-shaping tools for shoe-mount flash units influence the appearance of a subject. To create these images, I used different light-shaping tools in combination with a flash unit fired at a distance of 1.5 m (4.9 ft) from the subject. For the background, I created a simple sweep out of white paper. Always make note of what lighting tools you use for your exposures. This information, in combination with the camera's exposure settings, amounts to something of a lighting archive that you can consult when the need arises. To take this a step further, you can also use a second camera to take a picture of your set for complex lighting setups.

A small tip for beginners: pick a test subject and use readily accessible objects in your surroundings to practice influencing the quality of light. Use the wall of a room or different-sized pieces of cardboard as reflectors. Cover the cardboard with aluminum foil, use artificial parchment as a diffuser, or use mirrors to redirect light. You'll be amazed by the different lighting moods you'll be able to create with these rudimentary tools.

▲ Flash unit with no auxiliary light-shaping tools.

▲ Harsh and clear-cut shadows result from the pointed light of an unaltered flash unit.

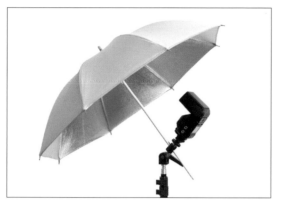

▲ Umbrellas are inexpensive and portable. Some have silver, gold, or white coatings, and others function as translucent light screens.

▲ Soft light but muddled shadows result from scattered light.

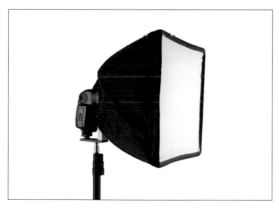

▲ A small soft box (30 x 30 cm/11.8 x 11.8 in), shown here with an adapter for a flash unit.

▲ Even with a small soft box, you can see that the light is noticeably softer.

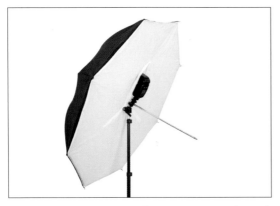

▲ An umbrella-style soft box (diameter of 100 cm/39.4 in) can be opened up just like an umbrella for the rain, which makes it very portable.

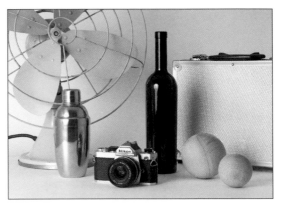

▲ Soft and subtle light is ideal for objects with matte surfaces, but it is not great for shiny objects because of its unattractive reflection.

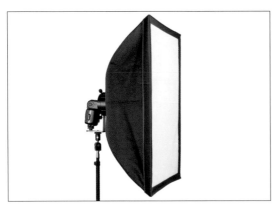

▲ A medium soft box (50 x 70 cm/19.7 x 27.6 in) offers quite a large area of illumination.

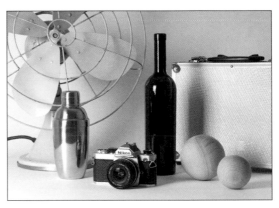

▲ Soft shadows and even light make soft boxes widely appealing.

▲ A strip light (here 22 x 90 cm/8.7 x 35.4 in) is a narrow soft box used to create light lines, especially along reflective surfaces.

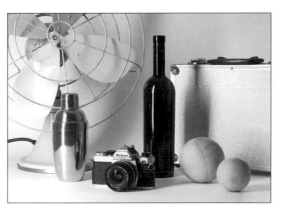

▲ Soft light with clearly defined light accents and soft shadows. The light lines accentuate the shape of the bottle.

▲ A snoot with grid, which is frequently used for auxiliary effect lighting.

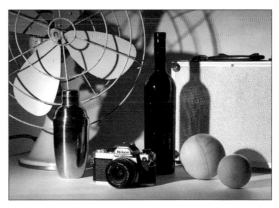

▲ Very dark and harsh shadows create focused lighting effects.

▲ Barn doors allow you to create a customized cone of light by adjusting the flaps.

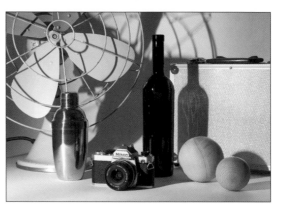

▲ Clear, dark shadows with sharply focused lighting.

▲ A beauty dish (diameter of 40 cm/15.7 in) is lined with silver.

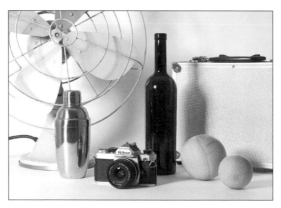

▲ Gentle, soft, but easily discernable shadows.

This test setup gives you an overview of the details you should pay special attention to when comparing the results of different light-shaping tools.

The exposures were purposefully taken in black-and-white to emphasize the distribution of light and shadow.

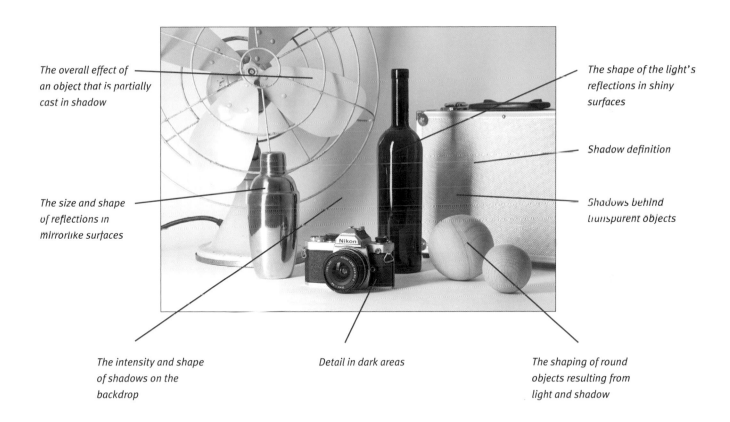

The overall effect of an object that is partially cast in shadow

The size and shape of reflections in mirrorlike surfaces

The shape of the light's reflections in shiny surfaces

Shadow definition

Shadows behind transparent objects

The intensity and shape of shadows on the backdrop

Detail in dark areas

The shaping of round objects resulting from light and shadow

Studio

Setting Up Your Own Tabletop Studio

The size and location of your tabletop studio depends primarily on what you intend to photograph. If you're planning on occasionally shooting small objects like watches or jewelry, working on a desk won't pose any problems for you. Larger objects—especially those that require complex lighting setups—may require the use of an entire room. If you plan on taking pictures of food, the proximity of the kitchen should also factor into your considerations.

The Simple Solution

The least expensive solution consists of a table pushed up against a wall, on top of which is a piece of white cardboard to create a backdrop sweep. For lighting, use a simple flash unit that can be manually controlled and connected to the camera via a sync cable. To create a pleasant, soft light, avoid directing the flash at the subject itself; instead, use another piece of white cardboard to bounce the flash indirectly onto the subject. You can lighten up shadows by placing another reflector on the other side of the subject.

A second flash unit will give you some freedom in terms of your ability to illuminate your photo shoots. You'll be able to create additional lighting accents, for example. With this setup, you'll have everything you need to take remarkable product shots for online auctions, for example, without having to make any large investments. You'll be able to regulate the quality of the light to a certain extent by using reflectors of different sizes and at different distances in relation to the subject. If soft light is called for, you can bounce the light off the room's white walls. Although it is quick and practical, this setup has fairly strict limitations in terms of how much you can shape and alter the lighting of your shoot.

A Mobile Studio

If you want to take on-site pictures for a client or capture the culinary artistry of a friend working in his or her own environs, it is easier to take your studio equipment to your subject than the other way around. A portable photo table gives you flexibility and the ability to set up shop regardless of location. You can find these tables in a variety of dimensions, and many models can be folded up for easy storage after a shoot. The surface is usually made of a white pliable plastic that is conducive to lighting from below. Larger photo tables can cost upward of several hundred dollars, but they can often be tilted to different angles. If you add a couple of flash units and the appropriate soft boxes, you'll be well equipped and able to work with soft lighting even while traveling away from the haven of your own studio.

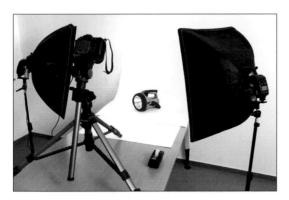

▲ A background sweep constructed out of white card-board and one or two soft boxes works perfectly well and is an easy setup for simple product shots. Illumination: Two flash units with 50 x 70 cm (19.7 x 27.6 in) soft boxes.

▲ The result is a perfect shot, without much effort.

A quick tip on a related note: Soft boxes are usually manufactured with steel rods to keep their shape. Assembling them can require some strength, and having to do this a few times every day can become laborious. You can replace the steel rods with fiber-glass rods that have roughly the same strength. They are much easier to bend, still provide an adequate amount of support, and weigh less. This will make assembling and disassembling your soft boxes much easier.

A small collapsible photo table.

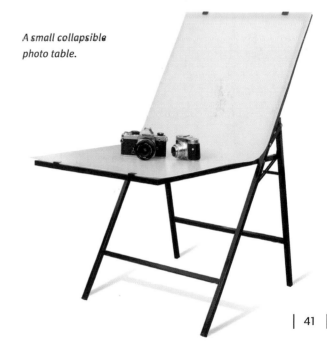

▲ *Also include the footprint for your lighting in your plan.*

A Stationary Solution

If you have even a portion of a room available to use, you can set up a small studio in your home. A coffee table or an emptied-out chest of drawers can serve as a your production table. You can use the drawers or the area under the table to store holding clamps, small mirrors, tape, filters, nylon cords, and any other handy tools while you're working. For lighting, two flash units with soft boxes will do the job, and two light stands will make sure your equipment is stable.

When they're not needed, you can collapse and store your stands and soft boxes by packing them away under the table or in a closet to save space.

Backgrounds can be held up with a few tacks or hooks in the wall. When all of this equipment is set up, it will take up an area of about five square meters (about 54 square feet), but if all of the equipment isn't needed, it will reduce down to one or two square meters (about 10 to 20 square feet).

A Complete Studio

In an ideal world, you will have an entire room available for your studio. Among other benefits, this allows you to leave your arrangement set up overnight. With some careful planning, even a small room can work as a very functional studio.

Start developing your home studio by sketching out a plan on paper. First draw all of the large furniture, such as the photo table and cabinets, at a 1:10 scale on a sheet of paper and label the individual elements. Then do the same with the lighting, the tripod for the camera, lamp stands with soft boxes, and so on.

It's advisable to plan for a certain amount of operational space around the camera and lights to leave you some room for adjustments as necessary. Next you can cut out the individual elements and trace the floor plan of the room on another sheet of paper.

▶ *If you have an entire room available for use, you can arrange it to meet your specific needs.*

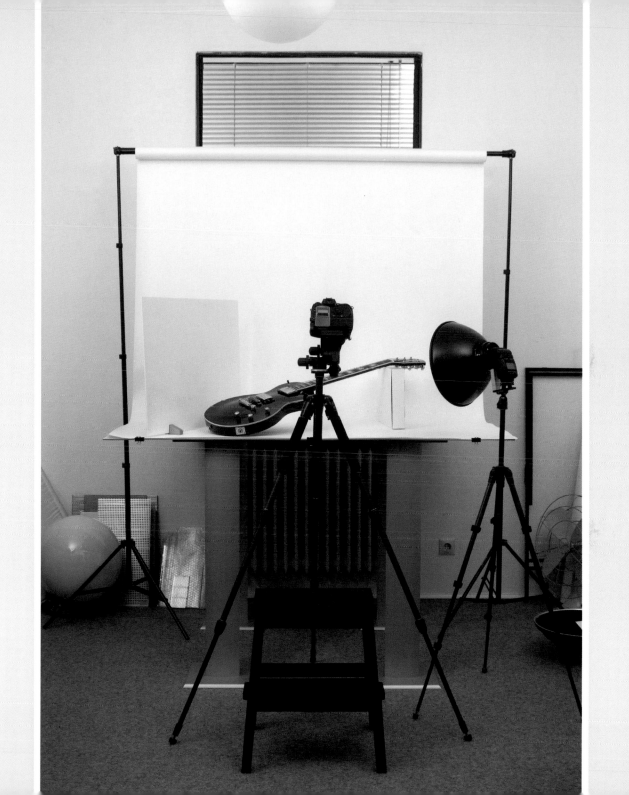

Don't forget to consider the height of the ceiling for indoor studios. On your sketch of the room also make note of the ceiling height at a few representative points, and note the location for all your furniture and the maximum heights at these locations. Also note the location of power outlets in your diagram. Now you can play around with the exact arrangement of the room by moving the pieces around the floor plan.

You can also use a graphic design computer program to define the floor plan and locations of the main items in your studio.

If you can't change the size and location of the major elements of your studio, you can start right away with preparing the room. All walls and ceilings should be painted white, and the floor should have gray carpet or vinyl. This will ensure that no unwanted color tones creep in to your exposures. Any windows should be darkened as much as possible. If you plan on taking any long-exposure images, you should use heavy black fabric to make the windows lightproof; otherwise, blinds on the windows should prevent any outside light from creating discernible reflections on your subject.

You can give yourself some extra space by placing the photo table opposite of the room's door. This will allow you to shoot larger objects or to use lon-

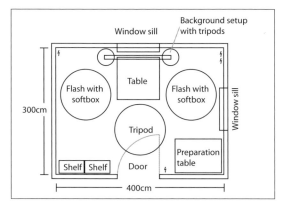

▲ *Taking the time to map out your floor plan intelligently will make for relaxing work later on.*

ger focal length lenses because you can stand in the hallway or the neighboring room to shoot the image.

The Photo Table

The central feature of your studio should be your photo table. If at all possible, you should be able to access it easily from all sides and should have some extra space surrounding it so you can set up the lighting. In most cases, you can use a discarded desk, an old kitchen table, or a board resting on two sawhorses.

If you plan to shoot or illuminate from below your subject, you'll need to use a glass photo table surface, and you'll have to create a setup of your own.

This has the advantage, however, of allowing you to create a photo table to meet your specific needs.

The table used in this book, for example, consists of a 100 x 100 cm (39.4 x 39.4 in) glass plate that is 1 cm (0.4 in) thick, which I had cut by a local glazier. The sheet of glass rests on four 85 cm (33.5 in) high MDF (medium-density fiberboard) columns painted silver and topped with a piece of foam rubber to prevent any scratches to the glass. The working level of 85 cm (33.5 in) allows me to position a flash at a fairly large distance below the subject. To take shots from above, it is easy to remove the tabletop and place it on shorter legs. These 15 x 15 x 25 cm (5.9 x 5.9 x 9.8 in) blocks—also made of MDF—can work as support structures or as decorative objects when they are not being used as table legs.

Sweeps and Background Systems

The standard backdrop for tabletop exposures is a sweep made with white paper. You can purchase rolls of paper appropriate for this use from stores that sell photography accessories or from paper wholesalers. A paper roll with a width of 100 to 150 cm (39.4 to 59.1 in) will be more than adequate in most cases. There are a variety of methods for affixing a paper roll to the wall, from rods that attach to light stands to wall mounts that are capable of supporting multiple rolls.

▲ *The paper backdrop sweep is supported by a rod and two adjustable cords hanging from the ceiling . . .*

▲ *. . . and is attached to the tabletop with small clamps. Plastic rail clamps prevent the front edge of the paper sweep from tearing.*

The simplest method is to screw two stable hooks into the ceiling and hang the paper roll using rope and a rod. So you can change the height of the paper roll and the curvature of the background sweep, don't knot the ends of the rope around the rod—use cord clamps instead. You can hold down the front edge of the paper by using plastic rail clamps and two clamps at the edge of the table.

Additional Devices

A second table can be useful as storage for accessories, a staging area for props, and a temporary place to keep subjects when you have a lot to photograph. With some luck, you'll come across a discarded paper cabinet from an architecture firm. These cabinets are ideal for storing background cardboard, large color gels, and other objects that shouldn't be bent or rolled. If you intend to control your camera with a laptop, you'll need a movable table. Collapsible trolley tables are practical for studios—you can store all sorts of equipment on their lower levels, and you can wheel them into a corner to save space when you don't need them. A small stepladder can also come in handy for shooting from above, changing the backdrop, and so on.

Stands

A stable tripod with an adjustable tilt head is a basic piece of equipment for any studio. Three-way pan heads offer you precise control over the angle of your camera. They also allow you to read the angle on a scale, which you can use to recreate your shooting setup at a later time, as long as you also note the exact position of the tripod.

Stands with extensions are necessary whenever you plan to shoot your subject from above, and an integrated bubble level is helpful for positioning the camera precisely. Special studio tripods can be individually adjusted, but it makes sense to use one only when you have a large studio space. They are also very expensive.

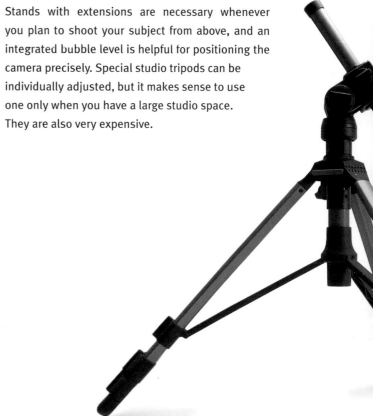

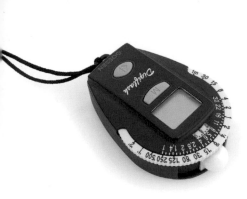

Even in the age of digital photography, a flash meter is a useful tool. The best way to prepare a picture for digital post-processing is to make the original exposure with the best lighting possible.

Clamps, clamps, clamps. There's always something that needs to be fastened in the studio.

Filters are available in many styles, for many purposes. In tabletop photography, they're mostly used to create special effects.

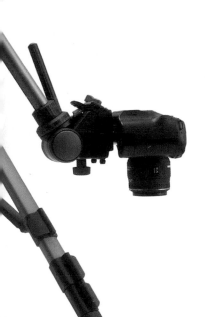

Tripods with extension arms are the right choice for photographing subjects directly from above.

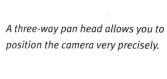

A three-way pan head allows you to position the camera very precisely.

Useful Accessories

When working with a tabletop studio, you always need to secure, fasten, adhere, or brace something. Lights must be precisely set so that some areas are shaded and others are brightened, the subject of your shoot must be dust free, and the draping in the background must fall perfectly in the correct position. For this reason, it makes sense to keep a small arsenal of aids—it would be unfortunate to interrupt the shoot to go get some glue.

Adhesives and Anchorages
Generally, the purpose of adhesives is to attach two objects permanently. For a tabletop studio, however, adhesives need only to bind objects until the end of the photo shoot. The ability to attach a variety of objects together in such a way that is invisible to the camera is much more important than the durability of the adhesive. In fact, it's best to remove any residual adhesive after the shoot so the objects end up in the same condition that they started. If you aren't able to use glue because the surface material of your subject is too sensitive, small strong magnets are an alternative. Magnets are also great for marking the position of objects on the photo table; just slide a thin sheet of metal under the background sweep.

▲ *Matte reusable tape allows you to make readjustments as necessary, even when working with delicate surface materials.*

If you need to invisibly hang parts of the subject from the ceiling, you can use transparent nylon twine and attach it with a small dot of hot glue.

Adhesives
- Small glue gun
- Superglue
- Reusable tape
- Double-sided tape
- Invisible tape
- Spray glue

Anchorages
- A variety of clamps in all sizes
- Transparent nylon twine for suspending objects from the ceiling
- Pins
- Magnets

Supports and Shims

Small objects can be supported by a small bit of modeling clay or foam rubber. Both prevent objects from sliding accidentally. You can also build larger structures out of Styrofoam blocks or small boxes that can be held together with a few drops of hot glue or a handful of toothpicks. If the larger support objects are hidden behind or below the backdrop —underneath a piece of draped velvet, for example—their color doesn't matter all that much.

If, however, the supports are on top of the sweep backdrop, it's another story. Even if the objects are not directly visible by the lens, they can still alter the light and function more or less like reflectors. This can cause unwanted light to shine on areas of your subject. For this reason, you should build a collection of small boxes and Styrofoam blocks that are painted with a water-soluble, matte acrylic paint in a neutral gray.

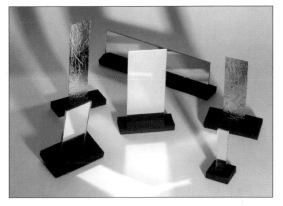

▲ *You can easily build reflectors for fill lighting out of small pieces of mirrors or shiny foil. These allow you to direct light to a targeted spot in your subject.*

- Pieces of foam rubber in a variety of thicknesses
- Building blocks
- Small and large white boxes
- Styrofoam blocks
- Modeling clay

Influencing Light

You don't need to spend a lot of money to create different lighting accents with a shoe-mounted flash unit. Mirrors, for example, function as independent sources of light when they reflect the discharge of a flash. It is relatively easy to use them to direct light toward inaccessible areas of the subject without

having to use another flash. By covering them with color gels, you can also create colorful effects in your images. Aluminum foil, gold glazed paper from last year's Christmas decorations, or even small bits of white paper are useful tools to brighten areas of the subject effectively and to cast interesting edges across the scene.

Light Accessories

- Small mirrors
- Silver and gold glossy foil
- Black and white construction paper to darken and brighten areas of the image accordingly
- Colorful boxes and papers
- Color filters

Organization

Even though it isn't strictly necessary to have the areas to the right and left of your photo table well organized, it can be very helpful to maintain something of a basic order throughout your tabletop studio. Nothing is worse than constantly searching for some missing accessory. An old dresser with several drawers can be perfect for storing and keeping track of your collection. Open shelves have the added advantage that your equipment is always easily accessible, but they can also accumulate dust quickly. Shelving units with glass doors are ideal.

▲ As much as possible, clean up dust ahead of a shoot with a brush; otherwise, cleaning up your arrangement after it is set up can become a real time-consuming process.

The Battle with Dust

The worst enemy of tabletop photographers is dust. It's not always a problem, but dust can be a real nuisance when you have set up your entire arrangement and then you discover that it needs to be cleaned.

Get in the habit of cleaning all your objects before using them in a shoot, and try to store them in such a way to protect them from dust as much as possible. The best tools for cleaning are standard household cleaning products that aren't too strong, such as window cleaner and alcohol. Antistatic towels and eyeglass cleaning cloths also prove their worth

when objects need to be cleaned without moisture. If you nevertheless need to clean your subject after you have arranged everything, you can use a bellows to blow away dust in the same way that you would clean your camera sensor. You could also use a fine brush or a cotton swab, which can easily be moistened to pick up the dust better. If you plan to leave your arranged subject out overnight, cover it with a clean, lint-free towel.

Give some thought to what you put on the floor of your studio. Carpet binds the dust so it stays out of the air. Dust in rooms with smooth floors tends to get kicked up in the air over and over again and always seems to land in the worst possible spot—directly on your subject.

Cleaning

- Small bellows and a brush for precisely removing dust
- Window cleaner
- Rubbing alcohol (to remove residual adhesive)
- Lint-free paper towels
- Cotton swabs for cleaning hard-to-reach areas

General Tools

To conclude, here's a small list of the tools that no studio should be without:

- Box cutter, metal rule, and cutting mat
- Scissors
- Glass bottle with pipette for precisely positioning water droplets
- Hammer and nails
- Tweezers
- Small hacksaw
- Wire in various thicknesses
- Fine brush for applying liquids

Specific areas of dust can be cleaned with the help of a small bellows.

Backgrounds and Props

The focus of a photograph naturally belongs to its main subject. The background and the surrounding props are almost as important, and they play a large part in making an image successful. For this reason, you should gradually build up a store of props so you will always have something appropriate on hand.

There's much to discover in craft stores, hobby shops, and home supply stores. You'll find wood surfaces, textured paper, felt, fabric, and much more. Most importantly, unusual wrapping paper and colorful plastic film can make interesting surfaces. A visit to a local metalworker or stonemason can also yield useful materials. Fragments of precious stones and textured metal sheets work really well for photographs of jewelry.

Last but not least, a simple walk through nature can be a great way to collect useful adorning materials—dry leaves, interestingly shaped branches, decorative twigs, mosses and grasses, snail shells and seashells, driftwood, river pebbles, and so forth. Any of these objects can be used to accent and improve your picture.

When you're at flea markets, keep an eye out for anything out of the ordinary. Old eyeglasses, tools, sports equipment or technical equipment from your grandparents' era, porcelain, silverware, aged metal, and wood objects covered with patina—in short,

▲ *Printed photos from large-format printers can function well as a backdrop.*

watch for anything that can add value to an image when used appropriately.

You can also create individual backgrounds out of simple supplies, such as a brush and paint. Broad and quick brush strokes on cardboard or canvas can create attractive patterns. You can alternatively spread the paint with a trowel to create a heavy effect or with a sponge to create something subtler. Even simple gypsum plaster from a hardware store, which can be used to imitate the textures of concrete or plaster, has the potential to be an effective background. In gypsum plaster that isn't dried yet, you can use different shaped objects to create distinctive

impressions. You can also create a rust texture by brushing vinegar on a sheet of iron and letting it sit for a few days.

One more interesting option is printing photos on a large-format printer and using them as backgrounds for your photo shoots. Blue skies with interesting cloud shapes, sunsets, picturesque landscapes, and so on can be integrated into your pictures effectively with a little craftiness and the right lighting. This trick isn't just useful for creating backdrops; you can also use large-format prints to create intentional reflections in your subject. You might, for example, position a panorama of a mountain in such a way that the lenses of the ski goggles in your image reflect the mountaintop.

The need for props in commercial photography includes standard items and seasonal accents, as well as accessories for special effects, such as acrylic ice cubes, artificial snow, imitation water backdrops, movie blood, cobweb spray, fog machines, artificial turf, and more. After a while you'll start to accumulate lots of props that will have to be stored somehow and, of course, retrieved again later. A method of organization is therefore very important for your props. Finding the space to store everything can also be a challenge.

▲ *You can intentionally create rusty surfaces by brushing vinegar onto sheets of iron.*

▲ *Artificial snow is made of plastic flakes and can even be used in summer.*

▲ Corrugated cardboard, rusted metal, frosted glass, stone, perforated plates, tiles, and paper—just some of the materials that can be used as backgrounds.

In Practice

Light Composition

With the help of several examples, I will illustrate how to handle the practical execution of several photographic objectives in this chapter. But before I do, let's start with the fundamentals of light composition.

Key Light

The key light should always be the dominant light of an exposure. Its basic purpose is to illuminate the entire scene. It determines the prevailing direction of light and, accordingly, the direction of shadows. In natural settings there is only one key light: the sun. For this reason, any picture that appears to have more than one light source causing shadows to run in multiple directions appears unnatural to the human eye. You should always first decide where the key light will point when developing the concept for a shot; when it is in place, you can start to think about fill and effect lighting.

Fill Light

Fill light works just like the name implies: it lightens up any shadows created by the key light. However, there is no reason why fill lights have to be independent sources of light—pieces of white cardboard, Styrofoam, and other reflectors that redirect the key light can function perfectly well as fill lights. Regardless of how the light is created, fill light is usually soft and should be weaker than the key light so it doesn't cast any shadows of its own.

Effect Lighting

Effect lighting creates lighting accents, usually to alter the appearance of a specific part of the subject in your image. Small flashes that are capable of discharging a low level of light are ideal for effect lighting, but mirrors and other reflectors can also do the job. When they are carefully placed next to the subject, they can function just like a small flash and direct light in a very targeted way. With a little work, you can convert an old slide projector into a projection spotlight, and its bright lamps can create the look of the setting sun in your images. The possibilities for effect lighting are limited only by your imagination.

Background Lighting

Separately illuminating the backdrop of a tabletop scene can sometimes make the subject stand out well. Lighting the background can also create a number of other effects. It is important, though, to make sure that the background lighting doesn't affect the way the subject itself is illuminated; be sure to effectively deflect any undesired light.

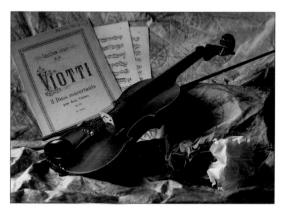

▲ *Key light only (a strip light from upper left); the shadows are still quite dark.*

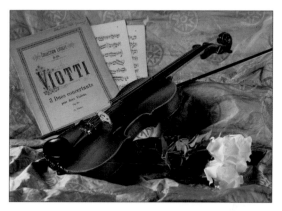

▲ *Key light and fill light (soft box from right); now the detail in the dark areas is perceptibly better.*

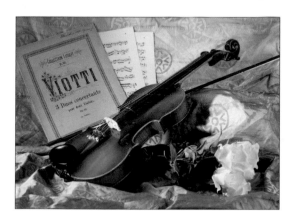

▲ *Key light, fill light, and effect light (snoot from lower left); the violin and the fabric receive more lighting*

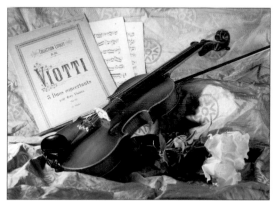

▲ *Key light, fill light, effect light, and background light (honeycomb filter from above); finally, the notes in the background are emphasized.*

Styling with Light

The direction of the light is also an important factor to consider when planning a shoot. With the right placement of the lighting equipment, you can accentuate the subject's shape and create different moods in your pictures. The most common setup for the lighting equipment is to place the side light more or less at a 45-degree angle to the subject and also slightly above it. Using a simple reflector as a fill light with this setup will create balanced lighting effects and realistic shadows—in other words, ideal light for product shots.

Sidelight is a fantastic way to accentuate the contours of your subject and to endow it with something special. The photographic intention here is to reduce the image to its essentials.

Lighting from above in combination with a fill light from the front is a common setup for food photographers. The goal is to create an atmosphere that is flooded with light and has few shadows.

Theater or stage lighting creates a dramatic mood, and tabletop photographers sometimes use it to create special effects.

Backlighting transforms the subject into a silhouette and requires strong lighting from the back. This technique is useful when you are shooting an object that will later be isolated from its surroundings. You do, however, have to be careful that the edges of your subject are not overexposed.

There is no one-size-fits-all method of creating effective lighting for every shot. The only rule is to do whatever the subject requires. The exposures on the facing page provide an overview of the results from basic lighting setups. Each shot was composed with a single flash unit attached to a 50 x 70 cm (19.7 x 27.6 in) soft box at a distance of 1 m (3.3 ft) from the subject.

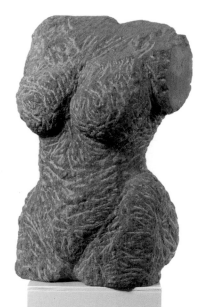

Torso: Susanne Werner

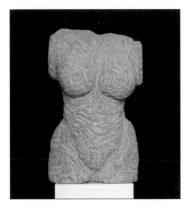

▲ Light directly from the front appears flat and creates few, if any, shadows.

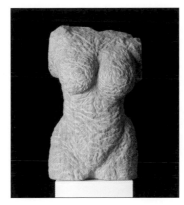

▲ Sidelight at an angle of about 45 degrees creates a three-dimensional effect and good shadows.

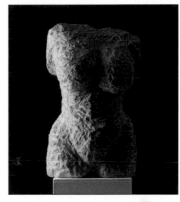

▲ Total sidelight emphasizes the subject's contours and puts the focus on the subject's surface texture.

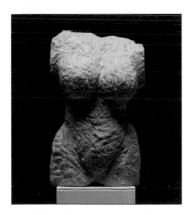

▲ Lighting from above usually creates an undesirable division of light and shadows; the shadows here need to be lightened up.

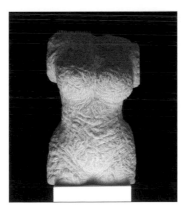

▲ Theater light from below creates an unnatural effect, but it works very well for creating dramatic moods.

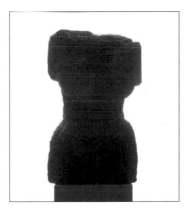

▲ With backlight, the subject is reduced to an outline and direly needs to be lit from the front.

Displaying Surfaces

Effective images depend on more than the proper arrangement of lighting alone. They also depend on the correct representation of surface materials.

The following tips should help you choose the correct lighting and should serve as a guide for what to do in different circumstances.

Shiny metal:
Reflecting black and white surfaces off this material establishes the impression of a chrome surface.
Light:
Soft boxes, reflectors

Matte metal:
Textured metal surfaces are often cast in colored light.
Light:
Soft boxes, spotlights, honeycomb filters, color filters, or colorful reflectors

Transparent shiny surfaces:
Reflecting color gradients off these surfaces makes transparent surfaces very visible.
Light:
Soft boxes, reflectors

Matte surfaces:
These do not have fussy characteristics; you can concentrate entirely on constructing the shadows.
Light:
Soft boxes, umbrellas, indirect flash, hard and soft light

Shiny surfaces:
Viewers will be able to tell how shiny these surfaces are only by seeing reflections in them.
Light:
Soft boxes, reflectors

High-contrast surfaces:
The softer the light, the less risk you run of underexposing the dark areas and blowing out the bright areas.
Light:
Soft boxes, diffusers, indirect light

Glass:
Light and dark reflections in glass surfaces create the impression of transparency and three-dimensionality.
Light:
Soft boxes, strip lights, reflectors, shades

Textured surfaces:
Leather, coins, wood, stone, fabrics, and so on. Sidelight emphasizes the surface texture of these materials.
Light:
Pointed light, soft boxes with honeycomb filters

Transparent surfaces:
These surfaces look most realistic when the viewer can see objects behind them.
Light:
Any light-shaping tools

Pure White Backgrounds

If you ever need to photograph an object in front of a pure white background, brighten the backdrop as much as possible so it is overexposed. To do this, you need to use lights for the background that are completely separate from the light you use for your subject. Two flash units with either small soft boxes or wide-angle diffusers will create ideal even illumination. To keep your subject from becoming a backlit silhouette, you also need to create some fill lighting from the front. To do this, you can use the camera's internal flash, an attached shoe-mount flash, or a separate independent flash unit with a soft box attachment. This lighting setup will create classic backlighting conditions.

You can mitigate the effects of stray light by setting up pieces of white cardboard on either side of the subject as a backlight screen. If you set up the flash units without soft boxes, you can also use these pieces of cardboard as reflectors to distribute the light as evenly as possible across the backdrop.

If you position your subject in the area between the background and the backlight screens, it will still receive side lighting from the two flash units that are set up to illuminate the backdrop. If you move the subject forward slightly, the background lighting will have less of an effect on it, thanks to the backlight screens.

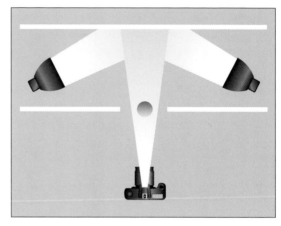

▲ *To evenly illuminate the background, use two flash units with small soft boxes.*

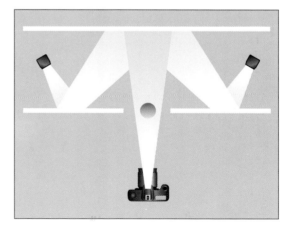

▲ *Alternatively, you can use backlight screens as reflectors to create uniform light on the backdrop with indirect light.*

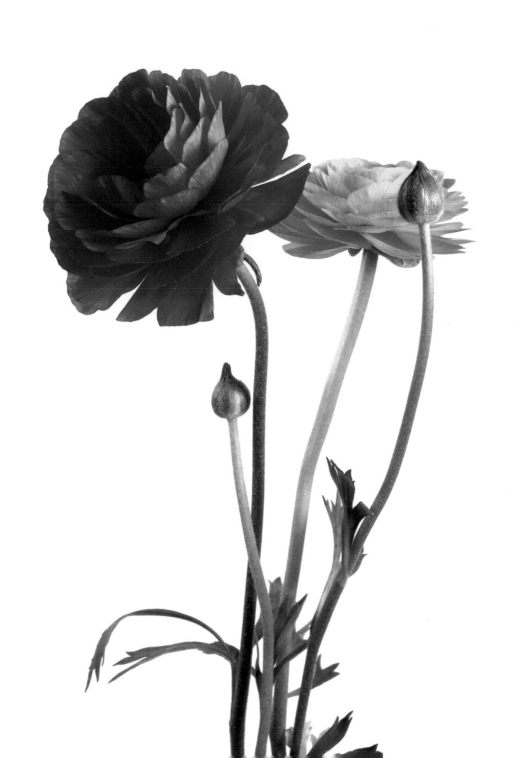

Pure Black Backgrounds

Black backgrounds enable photographers to emphasize color and to bring the shape of an object to the viewer's attention.

Creating an unblemished black background, though, is not easy. Simply positioning your subject in front of a black surface usually leaves something to be desired, because one of two things happens: either the subject ends up being too underexposed, or the background doesn't actually appear black. Any dust particles on the background will catch the flash and make the background look more like a starry sky than a pure black one.

You can avoid problems like these by setting up your shot properly. It's best to use black velvet or a similar fabric for the backdrop that will absorb light readily, but you can also use black or even gray cardboard. The important secret, however, is that you shine as little light as possible on the backdrop. You can accomplish this by shielding the key light from the backdrop, partly by using a honeycomb filter and partly by distancing the subject from the backdrop. The lighting arrangement is similar to that of the pure white background, but in this case the light is shielded from the background. To achieve this, position two black pieces of cardboard on either side of the subject with a wide enough gap to not obstruct the dark background.

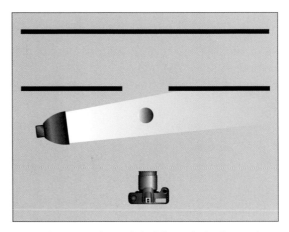

▲ *It is important that no light falls on the background, so you will need to deflect the light carefully.*

When choosing which lights to use, you need to consider that you don't want any light to fall between the two light screens. This means that side lighting is ideal. The larger the distance between the background surface and the light shields, the lower the risk that any light will spill through the gap. Since ambient light also affects your image, be sure to darken the room as much as possible.

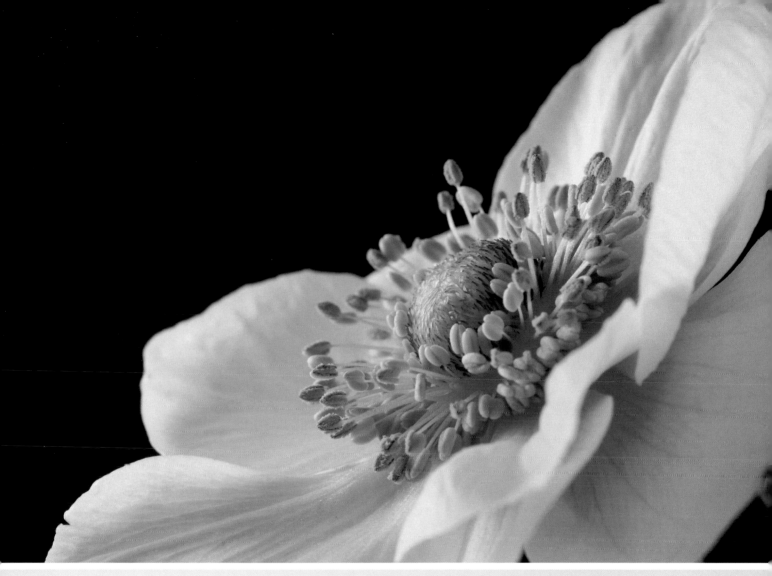

▲ *A black background emphasizes the subject's shape and color.*

Displaying Glass

Displaying glass is one of the biggest challenges of tabletop photography. In principle the process is quite simple. Everything that reflects in the surface of the glass conveys its shape. This means that by carefully positioning white and black surfaces around the glass, you can bring out its characteristic appearance.

But enough with theory. In reality it's not always easy to keep all of the unwanted reflections from appearing in the surface of the glass. More specifically, it's a challenge to keep the camera and the photographer from appearing in the image as reflections in the glass. Wear black because colorful clothing has a greater potential to stand out in the reflections. You can also use a long shutter-release cable so you can stand at a safe distance from the critical areas of the shoot. As you will read in the section on reprography, you can make the camera effectively disappear from the image by cutting a hole in a black piece of cardboard that is only large enough for the circumference of the lens. The windows of the room should also be as blacked out as possible.

After taking these precautions, most of the potentially troublesome elements of the photo shoot will be gone and you can focus on figuring out how to arrange the lighting. The saying "less is more" is especially true when lighting photographs of glass.

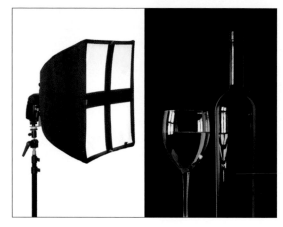

▲ *Use tape to create a cross on the face of a soft box to give the impression that the light reflected in the glass is coming from a window.*

Soft boxes and strip lights are best suited for these occasions because their reflections appear as bright strips in the glass. Umbrellas and umbrella soft boxes do not work well because they engender less appealing reflections in the glass.

You can achieve interesting results by taping cardboard to the face of a soft box. You can imitate the shape of a window, for example, or you can

▶ *Image on right: The reflections in the glass were created with two narrow strips of cardboard that were positioned next to the glass.*

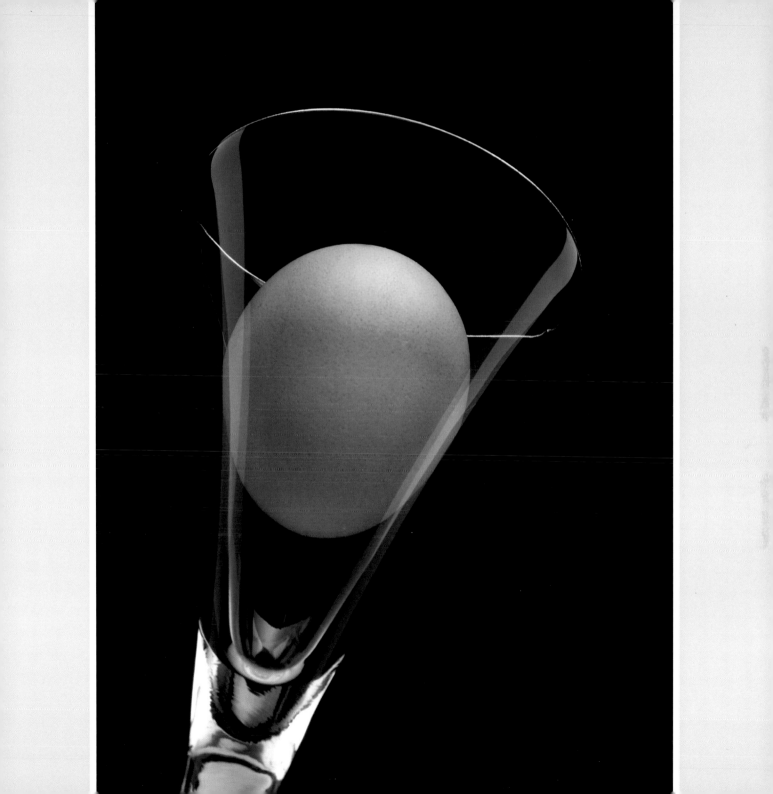

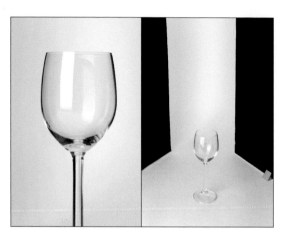

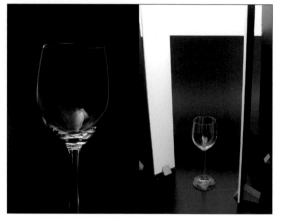

▲ *Glass in front of a light background: Two pieces of black cardboard produce dark contours along the edge of the glass and thereby create the necessary contrast with the background. A soft box was used to create the reflections in the center of the glass.*

▲ *Glass in front of a dark background: The flash was bounced off one of the room's white walls. Reflections from the narrow white reflectors to the right and left of the subject convey the shape of the glass. The indirect, soft light creates the slight gradient in the background and the bright edge along the top.*

experiment with irregular shapes. If the reflection is too bright, you can attenuate it with a large diffuser positioned between the light source and the subject. Additional reflections that work to highlight the shape of the glass can be created with narrow white reflectors.

Pay special attention to the edges of your subject because these are the visible parts of the transparent glass, and they are key to distinguishing the glass

object sufficiently from the background. Black and white strips of cardboard can also be placed next to the glass to create additional light and shadow effects in the reflections. You can alter the appearance and intensity of the edges by changing the width of the strips and their distance to the subject. You can create wide, striking reflections just as easily as thin, subtle ones that viewers will just be able to make out along the contours of the object.

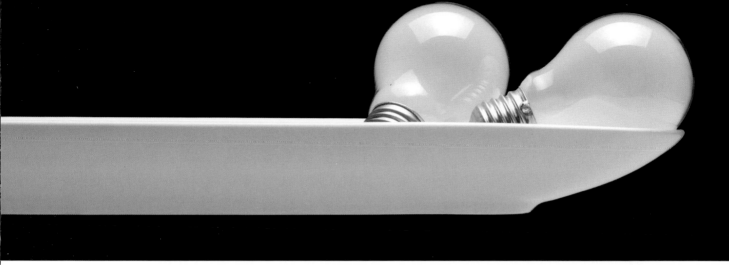

▲ *A soft box from above creates the reflections in these light bulbs; a white reflector, placed close to and below the shelf, evenly lights the objects from the bottom.*

You should clean glasses or any glass surfaces thoroughly before the shoot. Then try to avoid touching them after that. If touching them is unavoidable—for instance, if you need to decorate the glass after initially cleaning it—you should either wear light cotton gloves or use lint-free paper towels to protect them.

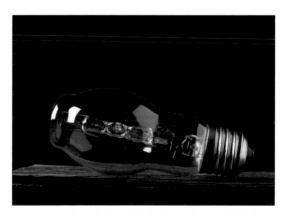

▲ *To create the thin line of light along the top of this light bulb, a 1 cm (0.4 in) wide strip of cardboard was placed above the subject.*

Freezing Motion

Shoe-mount flashes don't have the same power output as studio flash systems, but they are much faster. This makes them perfect for high-speed photography. The flash duration for some units can drop below 1/10,000 second. Here, for example, are the flash durations for the Nikon SB 26:

- 1/1 output power: 1/1,000 second
- 1/2 output power: 1/1,100 second
- 1/4 output power: 1/2,500 second
- 1/8 output power: 1/5,000 second
- 1/16 output power: 1/8,700 second
- 1/32 output power: 1/12,000 second
- 1/64 output power: 1/23,000 second

As a point of comparison, small studio flash systems generally used by amateur photographers can only reach 1/500 second.

Objects falling into liquids are one of the most popular subjects for high-speed photography, but this sort of shot requires advance planning and preparations in order to achieve a desirable result. Since it's impossible to predict the results with 100 percent certainty, these shoots always produce surprising shapes and forms in the splashed liquid.

After you have set up the background and the lighting, take a few test shots to verify that all of the

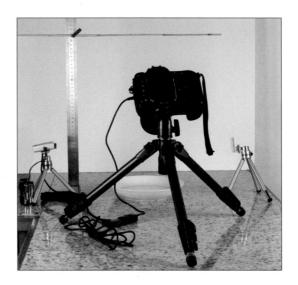

▲ *Using a photo sensor, you can control the right moment to release the shutter.*

elements of your shoot are optimally illuminated. The background, in particular, plays an important role; it should be evenly illuminated but not entirely white because viewers won't be able to distinguish the sparkles in the flying drops from the brightness of the backdrop.

You can make your first attempts by trying to press the shutter-release button at the exact moment that the falling object hits the surface of the fluid. This method will naturally lead to many failed attempts,

but you also might luck out and capture some spectacular results. The cherry on the opposite page was captured using this method.

An easier method, however, is to control the shutter release with a small photo sensor. By creating a series of test exposures, you can establish an exact trigger point, which can be marked with a ruler and a crossbar, for example. With a little work, nearly every shot will be a success. If your exposures are showing some undesired motion blur, you need to reduce the flash output and widen the aperture to compensate accordingly.

Shooting a liquid that is being poured into a container is less complicated but still requires many attempts to capture the perfect moment.

After trying to capture this type of image, you'll soon learn that it is advisable to cover a wide area of your work space with a plastic sheet or something similar. You also might consider setting up a temporary studio in a bathroom. Additionally, you can set your camera up behind a plate of glass to protect it and your lens from flying droplets of liquid. This won't have a noticeably detrimental effect on the quality of your image because it will be beyond the range of your camera's focus.

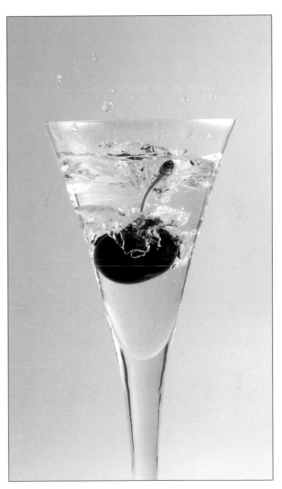

▲ *Capturing the right moment is the big challenge of high-speed photography.*

Long Exposures and Flash

Even in tabletop photography, there are occasions when it is desirable to include ambient sources of light. Consider situations when you need to photograph self-illuminating objects, such as computer monitors, cell phone screens, the illuminated controls of audio equipment, or candlelight. In normal studio exposures, these weak sources of light would be overpowered by the strength of the flash. There is a relatively simple solution to this problem: combining a shot with a long exposure time and a shot with flash. You can even accomplish this in one exposure without using picture editing software on a computer. You just need to take a couple of precautions.

The most important requirement is a tripod for your camera. Ideally you should be able to release your camera's shutter remotely to avoid camera shake. If you don't have a remote trigger, you can also use your camera's self-timer feature. While the self-timer is counting down, it gives the camera and lens a few seconds to steady themselves, which increases your chances for a focused exposure.

Using the settings for the flash exposure, take a few test shots. If the overall lighting suits your needs, then darken the room as much as possible and program your camera for a slower shutter speed. The length of the exposure depends on the luminosity of the various elements in your scene, but it can extend upward of several seconds.

Now you can get started with your actual shots. Switch the camera to manual mode and select the shutter speed that you determined for the long-exposure shot. Now the flash units will establish the prevailing lighting conditions at the front end of the exposure window, but nearly the only light that will reach the camera's sensor for the rest of the exposure time is the light from the self-illuminating object. If you choose a small aperture and a long exposure time, you can also manually fire the flash at some point during the exposure.

Furthermore, you can create interesting effects by using a flash unit set to a low output multiple times during a single exposure from different locations and with different color gels. Experiments such as this are nearly impossible with large studio flash systems. In this case, shoe-mount flashes have the clear upper hand, thanks to their modest size.

▲ *Using conventional lighting techniques with a flash, the self-illuminating display would hardly be visible. In this image, however, an exposure time of 1/8 second was selected to capture the glow of the display. The exposure was additionally illuminated with a soft box from the upper left and a flash next to the subject for effect lighting.*

Multiple Exposures

With film photography, before the triumphal march of digital post-processing, taking multiple exposures was a beloved technique for revealing details that would normally remain hidden, such as showing the interior of an engine while also depicting its exterior. This method was also capable of documenting temporal events in a single frame—the blooming of a flower, the movement of an animal, or the production process of automated manufacturing.

You can still accomplish most of these effects with image editing software, but the results of true multiple exposure photography are distinguished by a subtle transparency that is difficult to achieve with image editing, and there is also a certain charm and satisfaction in pulling off this photographic feat. One prerequisite for doing this, of course, is that your camera have a multiple exposure mode.

You'll also need to give some thought to the composition and lighting of your subject before getting started. A stable tripod and a remote shutter-release button are indispensable for shots like these because the different elements in each partial exposure must be in exactly the same place.

Next you need to determine the correct exposure for the composite image and divide it among the individual partial exposures. Since you're working in a studio, this means dividing the output of the flash by the number of exposures you plan to take. If your scene is properly exposed with a fully discharged flash (1/1) and you plan to take two partial exposures, for example, you would divide this output over the two shots and expose each of them with one-half of the flash output power. You could also expose one shot with one-fourth of the output and the other with three-fourths of the output, depending on which partial exposure you want to emphasize in your final composite image. When taking more than two exposures, simply divide the proper lighting for the composite image by the number of exposures you plan to use. The sum of each individual flash output should equal the total amount of light required.

Finally, you must also consider how to make changes to your scene between each exposure. After you have decided how to approach the changes, you can start taking pictures. Start with simple subjects to build up a reserve of experience, then move on to more complex scenes. In addition to changing the actual subjects of your images and altering the distribution of light across the individual shots, you can improvise additional effects by altering the focal length and the levels of sharpness for each partial exposure.

▲ This image of a violin in its case was made with three partial exposures. Two identical exposures were taken with the lid of the case closed, and one exposure was taken with the lid open. Another option would have been to take the first image with an empty case and open lid, the second image with the violin in the case and open lid, and the third image with the lid closed. This would have given the violin a degree of transparency so the interior of the case would be visible through its body.

Reprography

Reproduction photography includes special requirements for exposure, composition, and your lens. Positioning your camera at an angle that's even slightly askew can result in perceptible distortions in your images. A stable reproduction stand is more or less a requirement for this type of photography. Additionally, your camera lens should create as little distortion as possible, which is rare for zoom lenses. Throughout nearly the whole range of focal lengths, zoom lenses produce pincushion or barrel distortions. For this reason it's advisable to use a fixed focal length lens with single lens reflex cameras, such as a 50 mm macro or normal lens.

Digital point-and-shoot and bridge cameras are not well suited for subjects that require near perfect reproduction. If you end up using this type of camera, you will need to determine the focal range that produces the least degree of distortion, just as you would with a zoom lens. Any remaining distortion in your images will need to be treated with image editing software on your computer.

Take care to light your subject in such a way that eliminates any shadows and that evenly distributes light across the screen. Set up lamps or flash units on two sides of your subject; they should be positioned at a 45-degree angle and should be placed at the same distance from the subject. You can lay an

▲ Flash units with soft box attachments create an even, soft light that eliminates shadows effectively for reprography exposures.

additional sheet of glass on top of an object to weigh it down if it doesn't lie perfectly flat and produces unwanted reflections.

Instead of shooting with a wide-open aperture, program your camera to expose the image three or four f-stops smaller than normal. Here, in the middle of your camera's aperture range (around f/8), the performance of your lens is ideal; it creates the best possible definition of detail and focus.

Definitely plan to release the camera's shutter remotely—or at least with the help of the camera's self-timer—to avoid camera shake.

When working with reflective surfaces, such as

▲ Shooting through a hole in a piece of black cardboard is an effective way to prevent your camera's reflection from showing up in your photographs.

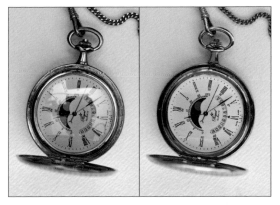

▲ Left: The camera's reflection is visible in the face of the pocket watch.
Right: A piece of black cardboard with white strips taped to its cover prevents unwanted reflections while creating desirable reflections on the edges of the pocket watch.

pictures that can't or shouldn't be removed from their glass frames, take special care to prevent the image of your camera from creating a reflection in your shot. One method for doing this is shooting through a hole in a piece of black cardboard.

Use a circle cutter or a box cutter to create a hole in a sturdy piece of black cardboard. The hole should correspond exactly to the circumference of the end of your lens so you can aim your lens directly through the opening. If your subject is only partially reflective, such as coins on top of a matte surface or gold leaf in a painting, using white cardboard that makes reflective areas appear bright and radiant will pro-

duce better results. If certain areas of your subject should be highlighted, you can adhere white paper to the appropriate places on the front side of the cardboard that's shielding your camera.

You absolutely should perform a white balance before taking your exposures to get a realistic reproduction of color. It's also a good idea to set a color test card or gray scale next to your subject, since this will help later when it comes time to adjust the colors in your image. Work in RAW format if your camera allows it.

Transmitted Light

Many transparent objects look their best when photographed with intentional backlighting. Think of glass marbles, orange slices, colorful lollipops, gummy bears, and much more. Arranging these objects on a glass plate and lighting them from below tends to bring out their most intense colors. This type of lighting (lighting through an object) is called transmitted light.

When setting up a shot this way, you should also plan to light from above to prevent the opaque areas of your subject from appearing too dark and to highlight the shape of your subject. Make sure the light from below is as even as possible. If you're using a flash below your subject, attach a light box or a diffuser and position it as far from the subject as possible. It's easier, however, to use indirect flash off a reflector. Use the same types of light above and below your subject, otherwise undesirable color casts will occur as a result of differences in color temperatures from the different light sources. Using a flash unit above your subject and a light box (such as one used for viewing slides) below it will inevitably create color shifts that you won't be able to sort out with image editing software.

When working with shiny surfaces, you can further influence the appearance of your subject by purposefully selecting the top light source to create appealing reflections.

▲ *Left: Transmitted light only. Middle: Incident light only. Right: Transmitted light and incident light.*

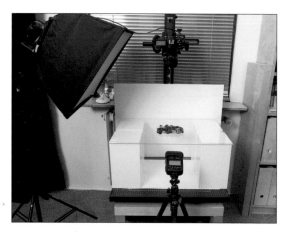

▲ *Reflect the flash off a white surface to create even transmitted light.*

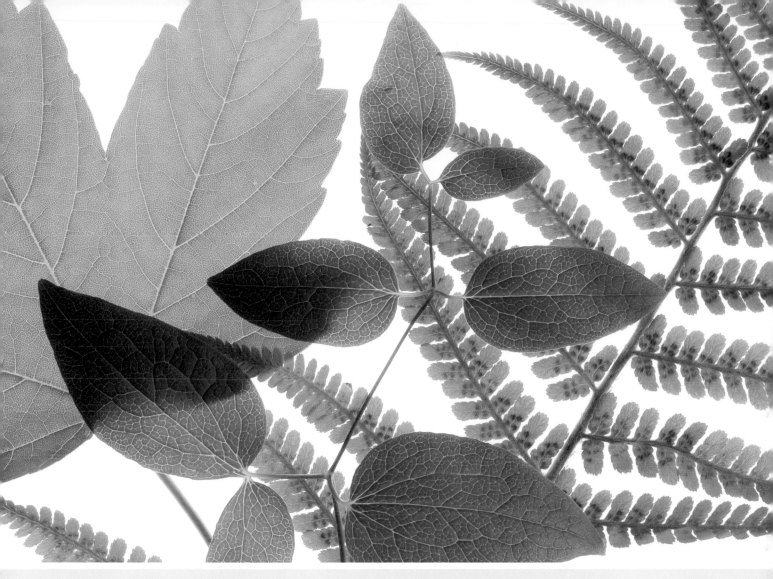

▲ *Plants make great subjects for transmitted light—the effect highlights details that viewers would otherwise not be able to see.*

High-Key and Low-Key Photography

These two extremes of photographic design are often used in nude and portrait photography. They are also capable of accentuating key characteristics in product shots when photographers carefully choose their lighting methods.

The goal with these types of shots is not simply to overexpose or underexpose your subject; high- and low-key photography involves emphasizing the prevailing tone values of a scene. High-key images emphasize bright tones, and low-key images emphasize dark tones. Both techniques are usually associated with a strong abstraction of the subject and a reduction of the subject to its essential qualities.

High-Key Exposures

The aesthetic of high-key exposures is light and delicate, visually suggesting concepts such as pureness and chastity. They are quiet and gentle. In the realm of still-life photography, high-key techniques are often used in combination with a tight focus in food photography as well as jewelry and beauty product images.

When working in a studio, larger soft boxes will help you eliminate harsh shadows and create an even quality of light in the foreground and the background. Using soft light, however, is by no means obligatory. Make sure the bright areas of your image aren't clipped and they still possess an adequate level of detail. Working in RAW format has huge advantages when using this technique.

Low-Key Exposures

Low-key exposures conversely emphasize the formal aspects of a subject. By using sparse light, usually cast from the subject's side, photographers can emphasize the characteristic shape of an object. Low-key photography lends itself to technical products that have sharply defined curves. The range of color is also greatly reduced—many objects appear mysterious or even dismal.

Studio photographers should take special care to control stray light, partly through using black pieces of cardboard that are placed between the sources of light and the camera. As for light-shaping tools, strip lights or a beauty dish with a honeycomb filter are good choices to start with. If you don't have a strip light available, you can bounce a flash off a narrow reflector or attach black cardboard to the face of a soft box to create a narrow strip of light.

▲ High-key photography emphasizes a subject's bright tones without sacrificing any level of detail in these areas. This image was shot with a beauty dish from the left and a soft box from the right for the background.

▲ This low-key image brings out the clear curved shape of the letter opener. It was shot with a strip light from the left and a narrow reflector for fill light from the right.

Baseline Images for Photomontage

To create exposures that fit well together in a composite photograph, it is necessary to plan your finished image before getting started. Not only must the lighting conditions be consistent across each of the individual images, but the background for each shot should be as close as possible to the color of the background for the final image to achieve a homogenous result. If you shoot one element of your image in front of a white background, for example, and then attempt to superimpose this element over a dark background later, you may end up with bright lines that are very difficult to retouch.

The perspective should also be more or less identical for each individual element so the composite image will retain an overall sense of cohesion. A few test shots can be helpful if you import them into a photo editing program and place them on top of each other with reduced opacity. You can give yourself a little more creative freedom by capturing the individual elements in several variations and then choosing the one that works best while examining them on a monitor. In the image on this page, for example, I had to take several shots to find the correct angle for the microphone.

Any element that will eventually need to appear out of focus in the final image will obviously have to be initially photographed out of focus. If you're not sure

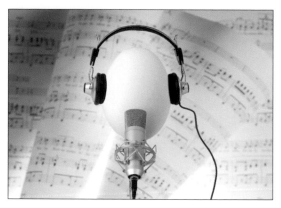

▲ *A simple photomontage made of several individual images.*

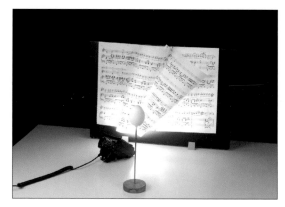

▲ *A small flash unit provided additional effect lighting for the background.*

▲ An inverted flower pot served as a placeholder for the headphones. I photographed the cable in several different positions so I would have a few different options to choose from when I created the photomontage.

▲ I also captured the microphone in a few different variations.

where in the final photomontage an element will be placed, you might consider taking several shots of it at different levels of focus. You can create blur effects in your image editing software after the fact.

When image elements need to be extracted from their backgrounds, it's easiest to illuminate them fully so all of their contours are clearly visible. This method, however, sometimes directly contradicts the overall feel that you want to cultivate in the finished image. The following workaround can help with this problem. First, expose the object using the appropriate amount of light for the final composite image.

Then expose the object again so all of its contours are sufficiently illuminated. You can create a starker contrast in difficult areas of your subject by placing white or black cardboard behind these areas. Now you can use an image editing program to create a mask based on the exposure that has been optimized so you can extract it easily and then use it in your final composite image. You will, of course, need to take both exposures with a stable tripod.

Photographing Masks for Extraction

Extracting intricate or even transparent objects can be a real test of patience, and the conventional means of doing this often fails to deliver satisfactory results. Intentionally backlighting your subject, however, allows you to create a mask for your subject that will help you extract even complex subjects in no time. The process is simple.

You'll need to make two different exposures of the same subject; the first will depict the subject in front of a white background, and the second will be a stark backlit silhouette. Both exposures must be made with a tripod so they will perfectly overlap. For this reason, neither the camera nor the subject can be altered in any way between the two exposures. It's also necessary to use a remote shutter-release button, since even a slight touch can create a small but significant shift between the two exposures.

For the first exposure, the lighting should be based on the conditions that you want in your final composite image. There's no reason to give much thought to the background lighting for this exposure since the background will later be hidden by the mask.

For the second exposure, change the lighting setup to illuminate only the white background, for which you might use a paper sweep or a large piece of white cardboard. It is also ideal to be working in a darkened room so ambient light doesn't influence

▲ *Exposure 1: The bonsai in front of a neutral white background; a soft box is placed on the left, and a white piece of cardboard for fill light is placed on the right.*

▲ *Exposure 2: The backlit bonsai as a silhouette. You can also see the black pieces of cardboard that are intended to prevent stray light from spilling onto the subject.*

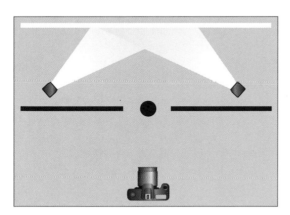

▲ It's critical that no light falls on the front of the subject in the backlit setup. Use black cardboard as backlight screens and, ideally, conduct your shoot in a darkened room.

▲ You can further edit the mask by altering specific areas of the image, such as intensifying the contrast, adding blur, or painting over areas so they can be removed from the composite image.

the lighting of the shot at all. You can effectively light the background by crossing two flash units, especially if you use their wide-angle diffusers to create as large an area of intense light as possible. Black cardboard set on either side of the subject will help prevent stray light from illuminating the subject, which should now look like a black silhouette in front of a white background. This exposure will serve as the foundation for the mask.

First, open exposure 1 in your image editing program, then duplicate the layer and create a layer mask. Next copy exposure 2 into this mask. After you do this, invert the mask so the subject appears as a white area on a black background. If you now delete the background layer, you will have an extracted copy of the subject in front of a transparent background.

It's almost always necessary to rework the layer mask by intensifying the contrast or blurring specific areas to create a smoother transition from the subject to the background. If the subject has a border you'd like to remove, you can select an area of the mask and edit its edges by coloring the necessary pixels white or black. Finally, you will need to create a new background layer or, more precisely, copy the

▲ In Photoshop, you can create specific settings for selected layer masks by choosing Refine Mask from the Select menu.

subject layer combined with the layer mask in your composite image.

It can take a bit of time before you obtain perfect results with this method; setting up and executing the backlit exposure, in particular, can require a little practice. After the initial learning curve, you'll be able

to achieve results that would be nearly impossible to achieve with conventional masking techniques or would at least take a huge amount of time.

You can process a number of different subjects if you use a separate set of flash units for the normal and the backlit exposures. This eliminates the time-consuming effort of changing and repositioning the lighting between each exposure. You can either manually turn the flash units on and off to switch between the two sets of lights; or, if you're working with radio remote controls, you can simply turn the receivers on and off. You can also attempt to switch between different radio channels. This option is often problematic, however, because it requires you to switch the channels on the transmitter that is attached to the camera. This invites the risk of shifting the camera position.

▲ The result is a perfectly extracted subject that can be superimposed over any desirable background. The amount of time required to extract this image manually would be tremendous.

Simple Product Shots for Internet Auctions

Snapping a good image of a jazz guitar poses several challenges. First, at a length of 105 cm (41.3 in), it's at the upper limit for the subject size that a tabletop studio can easily accommodate; and second, its surface is lacquered and highly reflective.

To prevent every piece of furniture from reflecting off the front of the guitar, I positioned it on a stand that leans slightly backward. I pointed the camera at a slight angle from above, or more specifically, at a 90-degree angle to the face of the jazz guitar. This means that the visible reflections come mostly from the white ceiling and the upper parts of the white walls. Some reflections—such as those of a bookshelf against the opposite wall, a dark door frame, and the photographer—are unavoidable, but as long as the viewer can't decipher what these objects are, you don't have to worry about them. They actually impart useful characteristics to the lacquered surface. Without any reflections at all, viewers wouldn't be able to tell how glossy the surface is because it would appear more or less matte.

Some parts of the guitar are chrome—such as the pickups, tailpiece, and tuners—and they should look like it. If these parts don't adequately reflect the white ceiling, you must use an additional reflector to highlight these pieces. The reflector also helps to emphasize the curvature of the guitar's body.

▲ *Illuminating indirectly by reflecting the flash off the white walls of a room is a simple and inexpensive method for creating soft studio light.*

Your goal when setting up shots like this should not be to eliminate reflections entirely, but to make sure the right ones are visible.

The lighting for this shot should be as simple as possible. Two flash units are positioned to the right and the left of the photo table at about the same height of the guitar and directed toward the white walls of the room. This setup will create a very soft light that will evenly illuminate the background, the white paper sweep, and the subject. By changing the distance of the flash units from the subject and regulating the output power of the flashes, you can control the intensity and direction of the shadows. If there aren't any white walls to use as reflectors on both sides of your photo table, you can flash indirectly off white pieces of cardboard.

These methods, though simple, may not produce perfect results, but they do produce results that are perfectly respectable.

In order to shoot large objects like this jazz guitar, a larger space is necessary.

Product Shots with a Light Tent

Simple, fast, and automatic—sometimes you wish that's exactly how product photography would always go, especially when the task at hand involves a slew of products that are close to the same size and require almost the same lighting, such as photographs for a parts catalog or an online store. Setting up each surface perfectly for each shot or making sure that every reflection falls in the right spot is simply beyond the scope of what's realistically possible in this situation. The constraints of time and money make this type of effort impossible. With that said, however, no one wants to sacrifice the quality of their craft.

Situations like this are perfect for a light tent. These tools offer photographers a neutral work space that is functionally independent from the ambient lighting conditions of the room. A tent provides many possibilities for lighting design, which is critical for mirrorlike objects such as the toaster illustrated here.

You can create intentional reflections, with the purpose of highlighting the shape of the object, by placing black cardboard strips in the tent. The tent should be large enough to allow you to set up the backdrop, as well as reflectors, shades, and so on, in addition to the subject. Most exposures require that you adjust the tonal values afterward to amplify the deep tones somewhat.

▲ *A light tent can mostly prevent unwanted reflections on shiny surfaces . . .*

▲ *. . . and offers a good foundation for touch-up work later.*

▲ Light tents are particularly useful for repetitive product shots that require similar lighting conditions, such as for an online store. Keep a note of the exact settings on the flash and the camera and sketch the floor plan of the stand, the angle of the tripod, and so on. You can use these details to reproduce the same conditions later if you need to shoot other products.

Colorful Light

You can create a variety of effects by using colorful light. You can purchase the necessary color gels from stores that sell photography accessories or from theater supply companies, where you can inexpensively purchase them by the meter or yard.

It is particularly interesting when multiple colors are used to illuminate a subject that has many different areas of light and dark. The color of the key light establishes the dominant tone of color for the scene, but you can use a second or third flash to color the shadows selectively. Modifying the intensity of the flashes will change the color and the size of the shadows. In this case, the key to success is the effect that is normally avoided at all costs in studio photography: double or multiple shadows.

Colored light can also be applied very discreetly to purposeful effect. When it is created with a spot light attachment, for example, you can create an accent light in an otherwise mostly monochrome exposure. The applications of this effect are limited only by your imagination.

Color gels are available at photography accessory stores and theater supply companies.

▲ *Objects with metal surfaces lend themselves to experimentation with colorful lighting.*

▲ *Gels can easily be cut and attached to the reflector of a flash unit. To prevent the gel from scorching when the flash is discharged at full capacity, leave some space between it and the reflector.*

▲ *Applying light from both sides of the subject results in shadows with intense color casts.*

Nature in the Studio . . .

Tabletop studios can produce good results with subjects from nature, where they can be captured in very controlled conditions. Wind and weather can't affect the shot, you can take your time setting up the lighting, and in the regulated conditions of the studio you can comfortably capture nature's good side.

If you would like to develop the most natural appearance possible, build a collection of suitable backgrounds by photographing natural scenes, such as a cloudy sky, a meadow, and so on, in a variety of perspectives. Print these backgrounds on matte paper, mount them on cardboard, and place them behind the subject but beyond the focal plane, and you can create images that would require tremendous effort in the wild.

One critical step in this process is making sure the background is free from shadows and is evenly illuminated. Effective lighting for shots like these can be created with a soft box placed above the subject, but a large reflector functioning as an indirect light source can also produce good results. The subject itself can be further lightened with white reflectors, and a spray bottle can simulate the appearance of rain.

Even exciting long-term projects such as the photographic documentation of the germination and growth of a plant are possible in a studio setting.

▲ *You have complete control of the lighting in a studio and can set it up in whatever way most benefits your subject.*

Plant several seeds so you can later choose the most photogenic specimen. It goes without saying that you can't bring plants or animals into the studio that are protected by nature conservation laws.

▲ *Working in a studio makes it possible to do photographic projects that require extensive preparation time, such as this garden cress labyrinth. This shadow-free light was achieved by reflecting two flash units off the room's white walls.*

▲ *Soft boxes create even light for macro exposures, which is not always available in natural lighting conditions.*

▲ *The shallow depth of field, the shadowless lighting created by two soft boxes, and the white background underscore the subtle color tones and give the images a feeling of lightness.*

· · · The Studio in Nature

Another way to photograph nature in the controlled conditions of a studio is to take your studio into the wild. Here again, compact or system flash units have a substantial advantage over larger studio flash setups. Thanks to their battery operation, they're completely independent from power outlets and are pleasantly small and light.

In principle, any of your light-shaping tools are available for use, including umbrellas, soft boxes, and so on, but flashing indirectly off a large folding reflector is also possible.

When shooting in nature, your background will most likely be many times farther away from the subject than it would be on a photo table in your studio. This means that you will probably have to provide additional lighting to prevent the background from appearing dark or completely black. If this is not an option—because you are using an entire landscape panorama as a background, for example—you should use your flash to create fill lighting. This requires either a wired or wireless TTL control for the remote flash unit.

Alternatively, you can use the following procedure: Switch your camera to shutter priority mode and select an exposure time that is longer than or equal to the length of the flash sync speed, such as 1/125 second. Now adjust the exposure compensation

▲ Shoe-mount flashes are perfect for a portable studio since they don't take up much room and allow you to work with soft light that you can regulate even while in the wild. Here you see a 40 x 40 cm (15.7 x 15.7 in) soft box.

down one or two f-stops, and take a couple of test shots with around half of the flash power output. The background should appear somewhat underexposed because of the exposure compensation, and the subject itself should be adequately lit from the fill flash. If the subject appears too bright, reduce the flash output or increase the distance between the flash and the subject.

When you are outdoors, it's best to use radio-controlled triggers for discharging your flash units. The bright ambient light outside can cause problems for infrared release systems.

▲ *This shot, taken on a dismal day, featured a remote flash attached to a 50 x 70 cm (19.7 x 27.6 in) soft box that substituted for the sun.*

Light Brushing and Light Painting

Light Brushing

You can purposefully use the different color tempera-tures of light from a flash and other artificial light to simulate the quality of evening sunlight. Flashlights are particularly good for this since you can focus their light onto a small area. This allows you to paint your subject with light, just as you would paint with a brush.

Before you get started, you need a darkened room to reduce the influence of ambient light on your shot and a stable tripod for your camera. Switch your cam-era to manual mode, select a narrow aperture, and choose an exposure time of a few seconds. Then take a few test shots to see how long it takes you to create your desired lighting effect and how much the ambi-ent light is influencing your exposure. If your expo-sure window is too short for you to illuminate all of the areas you want, you can simply add a few extra

▲ *Light flashed through a cutout in a piece of black cardboard simulates a window near an improvised workbench.*

seconds to the exposure time. On your second test run, determine what the optimal flash power output is. Use a little less light than you normally would, since the light from the flashlight will factor into the final exposure.

During the actual exposure, the flash will discharge first to create the prevailing brightness for the im-age. During the remainder of the exposure window, use the light brush to paint any desired light accents on the scene. Instead of relying on an automatic dis-charge of the flash, you can fire it manually once or several times during the exposure.

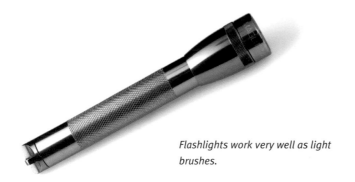

Flashlights work very well as light brushes.

▲ *A compact flash unit with a beauty dish creates a directed light. The "golden" lighting effect was created using a flashlight to "paint" certain areas of the subject with light.*

Light Painting

In the past few years, light painting has practically developed into an art form of its own. Artists enthusiastically paint shapes of light in landscapes and rooms. This technique can also create interesting results in tabletop photography, especially when used in combination with one or more flashes. In principle, light painting works in the same way as light brushing; the major difference is that you can see the source of light and the light trails it creates. LED lights are the primary brushes for this art because they are available in a variety of sizes, colors, and shapes.

Because the exposure times required for this technique are so long, you can fire the flash manually to create a variety of effects, such as creating the dominant mood, highlighting a certain area of the scene, or producing a visible image element composed of light. Depending on which objects you use as sources of light, your style of painting can range from points of light to broad strokes.

You can create further special effects by employing the strobe function of a flash. The speed at which you move the strobe flash through the scene and the frequency with which it fires determine the nature of the dashed light traces. Attaching color filters and black cardboard masks to flash units opens up a full range of additional possibilities.

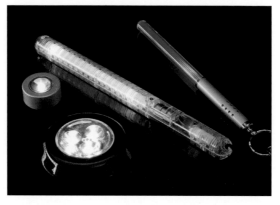

▲ *LED lights are available with a number of integrated features, such as the ability to flash, change color, or create chasing effects.*

If you wish to create specific shapes using these methods, such as the silhouette of an animal, create a template by cutting black cardboard into the shape of your choosing and use your light brush to trace along its edges. The possibilities for experimentation have no limits.

Since it can take a substantial amount of time to create these images, depending on the number and style of effects you wish to employ, it is necessary to use rather long exposure times. This might mean several minutes or possibly more, so it's necessary to create a plan before starting your shoot. Any lighting tools should be set up near the photo table so

you can quickly pick them up when necessary. A fully darkened room is required, as are black gloves and clothing, so you don't accidentally end up as a feature in your own picture.

It's impossible to look through the viewfinder for the duration of the exposure, so it can be a big help to set up a border on the photo table, or outline a "canvas", on which you plan to paint. This can be as simple as making a few marks with tape that are just beyond the area of the image. If you want to create a more exact outline you can use an old picture frame with the glass removed to surround your subject. This serves the double purpose of indicating the edges beyond which you should not paint and outlining the optimal focal plane.

When you attempt to create specific patterns or words, remember that you have to work backward because any shapes you create will be inverted, like mirror images.

▲ *This long-exposure image was illuminated with a strip light from the side to highlight the contours of the guitar and its strings.*

Strobe Lighting

A strobe light not only allows you to freeze motion in your photographs, it also allows you to display movement in individual steps. This is possible when multiple flashes fire in quick succession during an exposure. If the subject moves at all during the exposure, each flash will depict it in a different position. Depending on the length of the exposure, the speed of the subject, and the frequency of the flashes, the final result will more or less resemble a series of individual shots in a single picture.

In your flash unit's menu, the setting for hertz (Hz) indicates the frequency, or the number of partial flashes it will discharge per second. Before you can program the frequency and expose your shot, you need to time how long your subject's movement lasts by using a stopwatch. When you know the duration of the movement and the number of partial exposures you want to appear in your final image, you can calculate the flash frequency.

For example, suppose the duration of the movement (which is also the minimum exposure time) is 2 seconds, and there should be 20 individual steps of movement visible in the final image. You would need to set your flash to fire at a frequency of 10 Hz (20 partial exposures divided by 2 seconds of exposure time = 10 Hz).

It is best to work with as little ambient light as possible when you expose your image so the normal lighting in your studio doesn't affect your end product. You can carry out all other preparatory work in normal lighting conditions, of course. When you select a subject for your shot, consider how well it stands out from the backdrop. Since each flash burst is not very bright, you'll be limited to a somewhat shallow depth of field. You'll therefore have to work precisely to ensure that your subject never leaves the focal plane during the exposure. You should ideally determine the depth of focus by manually testing the range of sharpness and creating marks with pieces of tape on the photo table beyond the edges of the image. These marks will later function as a guide for the movement.

In addition to the strobe light, you can also use other flash units to illuminate the scenery. You can put emphasis on either the beginning or the end of the movement, depending on whether these auxiliary flashes are synced to the opening or the closing of the shutter.

▶ *Using the strobe light function of your flash, you can capture movement in a stepwise fashion similar to what you see here: the progression of an arm reaching for a ball of paper. The source of the sidelight is a Nikon SB 26 with a strip light and honeycomb filter attachments.*

Smoke and Fog

Using smoke and fog to create effects in studio images is always popular. Smoke consists primarily of the solid remnants of combustion, and fog consists of small drops of liquid that are suspended in the air. There are a number of methods for creating smoke and fog; the one you choose will depend on the effect you hope to achieve. The most common methods are described in the following sections.

Fog Machine

Fog machines evaporate a special liquid to create fog. Since even small fog machines have a relatively powerful output, it is more difficult to use them subtly than it is with the other methods described here. These machines are better suited for much larger areas than a tabletop studio. You can achieve remarkable results when using fog machines in combination with colorful flashes. You can get inexpensive small fog machines from theater supply companies, on the Internet, or at major music stores.

Dry Ice

If you're looking for something that produces fog that wafts just above the ground, dry ice is what you need. The downside is that it can be difficult to find and to store. Dry ice is carbon dioxide (CO_2) that is frozen to a temperature of -78.4°C (-109.12°F); it converts directly from a solid state to a gaseous one. The carbon dioxide gas is heavier than air and sinks to the ground. Since dry ice must remain so cold, it's not possible to store it for long periods of time, but after you obtain it, you should have two or three days to work with it before it all disappears into thin air. In terms of its photographic applications, dry ice is particularly useful when you need fog to linger near your subject or if you want to use it in very specific areas of your image. Dry ice isn't especially useful for simulating cooking because its gas sinks, but for scenes featuring chemistry labs, a witch's cauldron, or other fantastical scenes, it's perfect.

A small fog machine doesn't cost much, and it will produce interesting results. In the image of the guitar on the right, the fog machine is positioned directly behind the subject.

You can get dry ice in the form of pellets or blocks; look in your local telephone directory for vendors that sell it. There are also several companies that will ship dry ice if you order it over the Internet. If you go this route, though, you'll need to account for how the shipping time will affect the mass of your purchase. If you buy a block that weighs 5 kg (11.0 lb), there may be only 2 kg (4.4 lb) left by the time it reaches your doorstep two days later.

If you plan to use dry ice, you should familiarize yourself with the necessary safety precautions, and you should always wear gloves and safety glasses when working with it.

▲ *Tobacco smoke produces a beautifully delicate plume that always has a slight bluish hue.*

Hot Potato

Steam is a coveted element for food photography because it conveys that the documented foods are hot. The best-known trick for creating steam in a photo shoot is to use a hot potato.

Simply boil a large potato and place it behind your subject so it's not visible in your exposure. Immediately before you start to shoot, break the potato open. The resulting steam looks very natural both in images exposed with flash and long-exposure images.

The potato will usually steam for several minutes, so you should have enough time to take a series of shots. You can pick the best one later when you examine them on a monitor.

Tobacco Smoke

Placing a bit of tobacco in an old tea candle container is an ideal way to create smoke that can be precisely positioned in your image. Tobacco smoke rises very quickly and creates a very slight plume. This makes it less than perfect for covering large surfaces, but it is great for creating targeted effects in your scene. If you would prefer not to use tobacco, you can substitute incense sticks or cones without affecting the quality of the smoke.

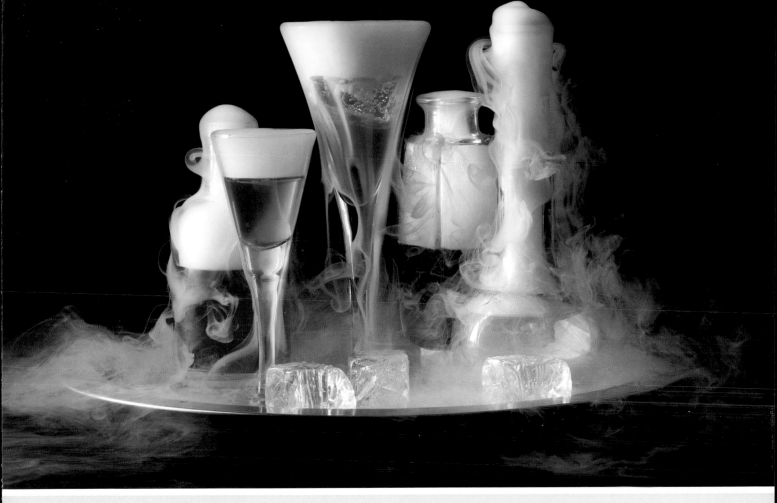

▲ To create this scene I used a paper funnel to drop pieces of dry ice into the glasses, which contained warm water that I dyed with food coloring. After making several exposures, I combined a few of them in an image editing program to create a consistent appearance of fog for each. I used a shoe-mount flash with a strip light attachment from the left and a white strip of cardboard for fill lighting from the right.

Food Photography

The technical requirements of creating images of food are no more demanding than taking photographs of other products; you must plan for different materials and surfaces and figure out how to create attractive lighting conditions and appealing conceptual approaches. The main difference, however, has to do with the enormous effort that goes into preparing subjects.

Hardly any other discipline of photography relies on so many tricks—imitating the head of a beer with whipped egg whites or shaving cream, using colored cream cheese to sit in for ice cream, airbrushing the crispy edge of a piece of toast, thickening gravy with glycerol, using wood glue for the milk in a bowl of cereal. Strawberries and roast chickens are often made up just as diligently as supermodels for a fashion shoot. We go through this labor of preparation to make food look perfect because our expectations have been shaped by commercials and advertisements. If photographers took pictures of prepared foods based on how they actually look when they're sitting on a table, no one would buy them. Food photography depends on idealization, exaggeration, and symbolism. In short, images of food need to be a feast for the eyes more than anything else.

In many cases, however, the technical challenges of creating images of food are the reason photographers have to reach into their bag of tricks. For example, what's a good way to prevent the chives resting on top of clear soup from sinking before I have enough time to take a few pictures? Just mix some gelatin into the soup to thicken it without changing its appearance.

Conception

In can be useful to jot down a few notes about what conceptual associations you want to achieve for each specific shot before getting started with the actual photography. If you were shooting yogurt, for example, you might write these notes: fresh, natural, white, bright, friendly, modern, healthy, lively, light, clean, young. This isn't a list of everything your final image must ultimately convey, but it is helpful for guiding your decisions about which accessories to use and how to stage the color and design for your shot. From this list, for example, you can make some immediate style decisions to support your conceptual direction, such as bright lighting for the background, modern plates and flatware, white linen, fresh fruit, and so on. One or two fresh-cut daisies thoughtfully positioned near the yogurt could also convey a sense of youthful freshness.

For coffee you might create the following list: hot, brown, aromatic, homey, well traveled, roasted,

▲ *For simple arrangements, there's no need for special food stylists. It's nevertheless important, though, that your scene is coherent and your image tells a story. This image suggests a vacation at the farm.*

▲ *The transition into blur and light and the tilted horizon convey a sense of youth and freshness. The lighting setup includes a soft box from the left and white cardboard for fill light from the right.*

freshly ground and brewed, comes from overseas, strong, black, fragrant. Decorating a scene with items that have similar connotations will produce a typical setting for images of coffee—exotic dark woods; old shipping containers; warm light; red, brown, and gold tones; utensils from foreign countries; and so on. Don't overwhelm your pictures with symbolism, though, otherwise you'll end up digressing into cliché. A subtle touch such as a golden reflection across the blurred area of the background, for example, is all it might take to imbue a picture of coffee with the right feeling.

If you look closely at the images in cookbooks and food advertisements, you'll start to recognize subtle symbolic hints that are intended to guide the viewers' emotions in the right direction. By no means is it wrong to look at the work of other photographers and ask yourself, Why did the photographer do that? What elements of style were used? Why does this picture work so well? What would I do differently, and why?

Arranging

In the professional realm, food stylists are responsible for selecting props and arranging the scene. Amateur photographers, however, are on their own and must attend to the work themselves, which makes a good plan of attack very important.

Start with shopping. It's best to buy fresh fruits and vegetables at farmers' markets, where you can easily evaluate the shape, color, and condition of the produce and select only the choicest pieces. Any other ingredients for which freshness is a factor, such as fish and meat, can be ordered ahead of time at most delis, or you can request to be notified when the next fresh delivery arrives.

After you've collected all the necessary ingredients, you can get started with arranging the scene. It's best to take one step at a time. Start by setting up the general composition for the shot using a separate setup that approximates your final arrangement as closely as possible. Any food that requires lengthy preparation doesn't need to be prepared at this step; you can use substitutes to sit in for these items instead—for a salad you could use a crumpled piece of paper, and for a steak you could use a brown piece of cardboard. The goal isn't to work out every last detail at this stage. The substitutes only help to create a first impression of the arrangement.

▲ *There are several styles of artificial ice cubes made from glass and acrylic. The only kind that floats in fluids like real ice cubes, however, is hollow artificial cubes made of acrylic. All the other kinds sink.*

If the composition of your subject matches your initial design ideas, you can move on to the second step: setting up the lighting. You should decide on as many settings as possible for your lighting equipment and snap a few test shots to examine the results.

Now you can devote some thought to the styling of the food. If all of the food is already prepared, all you need to do is replace the duplicate place setting with the real one, then you can get started right away with taking pictures. You'll especially appreciate this time advantage when you're working

with temperature-sensitive foods, such as ice cream when you either can't or don't want to use artificial ice cream.

Styling Food

This section could fill an entire book, but the focus here is on a few basic things to keep in mind and a few tricks of the trade.

One constant problem in food photography is that foods tend to lose their shape and color when they are cooked. This occurs mainly because foods lose water while cooking. For this reason, you should quickly steam or fry vegetables until they appear slightly glassy. Sear meat just until its pores close, then remove it from the pan and use a kitchen blowtorch to continue preparing it until its surface matches the look you want.

You can use a heat gun to make cuts of fish appear stewed. Heat guns are normally used to remove paint from old window frames and so forth. Heat the fish until its exterior turns a uniform white color. The interior of the fish will still be raw, but it will look great because it will still have its original plump and juicy volume.

To prevent a salad from collapsing on itself, you can put some florist's foam in the bowl, which will allow you to arrange and style the salad precisely. You can use toothpicks or pointed matchsticks to hold everything together, and if you're worried about any of the wood showing up in your image, you can cover it with radishes, cucumbers, shrimp, or any other ingredient.

If you need to take pictures of salad dressing on top of a salad before it drips down out of sight, you can use a touch of cornstarch, for example, to thicken it. This will make it stay in place on top of the salad longer than it normally would. Thickening liquids with additives so they don't flow as quickly and so they appear to have a bit more volume is widely applicable. Cornstarch or gelatin will cause tomato sauce to thicken and stay in place longer on top of a pile of spaghetti, and it will also look more

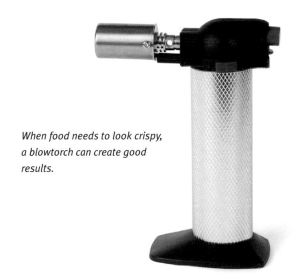

When food needs to look crispy, a blowtorch can create good results.

appetizing. Substituting wood glue for milk does the same thing. If the glue looks too artificial to you, you can obtain a similar consistency by mixing yogurt into milk to make it thicker. Experimenting on your own with such substitutions is a great way for you to figure out more of these tricks.

You'll encounter many problems that seem complicated at first, but there are astoundingly simple solutions that you'll easily figure out. Consider, for example, the challenge of creating an image of a pizza slice that has been perfectly cut from the rest of the pizza so it has clean edges. The solution isn't terribly complicated—first bake the pizza dough by itself, then cut a piece large enough for one slice and add all the toppings to this individual piece. After all the sauce, cheese, and toppings have been added, bake the slice for a second time, this time broiling it so the cheese melts and the toppings brown as desired. The slice will look cleanly sliced with sharp edges, and the dough won't be soggy from the tomato sauce. Your blowtorch will come in handy to brown the crust.

Small Tools

There are small tools you can use for styling food that are indispensable. Always keep an assortment of these useful items handy, such as fine and large brushes to apply oils and dressings, cotton swabs and lint-free paper towels for cleaning, cotton gloves to protect your subjects from fingerprints while you style them, and so on. Small plastic bottles with spouts are useful for pouring sauces and dressings or for making a creative embellishment in your scene. Tweezers are great for adding those finishing touches to your subject and adjusting one or two final details before you start to snap away.

Light

Food photography is all about light and playing with focus, so you can apply the following rule to many photo shoots: use a wide aperture and lots of soft light. Most professional studios position large soft boxes and strip lights above the subject to create abundant soft light, but you can achieve similar results by reflecting the light from a shoe-mount flash off a large piece of white cardboard. Eliminate any shadows underneath the food by setting up additional cardboard pieces as reflectors or by using an auxiliary flash for fill light.

Pay special attention to the lighting for the background because it makes up a large part of the general atmosphere of food photographs. It's often advantageous to illuminate the background brighter than the subject so the exposure will appear slightly

blurry beyond the depth of field when using a wide aperture. This uncertainty invites the viewers' gaze and leaves some room for their imagination.

Some photo shoots will naturally demand specific lighting. If glasses or bottles are featured in your subject, for example, you'll want to use the appropriate lighting, such as a soft box or narrow white reflectors, to highlight their surface and shape.

Since you'll most commonly be using a wide aperture, and since your subjects will almost never be larger than the size of a table, you should be able to handle most lighting requirements with no problems at all using two to four shoe-mount flashes, a soft box, and several mirrors and reflectors. The compact size of shoe-mount flashes and the ability to manually control their output present many advantages for food photographers. If you want to create a number of lighting variations, you should test them while using the dummy place setting and keep detailed notes about which flash settings you like best. This will allow you to adjust these settings quickly when you take your actual exposures, making it possible to take all of your shots before steaming food cools too much or ice cream starts to melt.

Exposing

After you've made all the necessary preparations,

▲ *Create a control exposure by using a gray scale or a color test card.*

you can get down to the actual work of exposing your images. This part of the art of photographing food takes up only a small portion of the total amount of time required to prepare a shot. Controlling your camera with a laptop has many benefits when taking pictures of food. Any additional effort required to set this up is usually well worth it. In any case, you should import your exposures to a computer as quickly as possible to examine your results on a large screen. Viewing them only on the small display of your camera is not a strategy for success.

Since color is such an important element of food images, using a gray scale can be a big help. The yellow and brown color tones of bread and other baked

goods aren't always easy to reproduce and often take on an unappetizing tinge of green. Working in RAW format and using a calibrated screen are good ways to play it safe with the colors in your images.

Some exposures that have specific time constraints require the help of an assistant. Take, for example, the much-loved trick of pouring salt into beer to cause it to foam right before exposing the subject. You'll need both hands to carefully funnel the salt into the glass so you don't leave any evidence of your trick on the inside walls of the glass. This means you won't have any hands free to release the shutter. You can try to handle this problem by using a remote shutter release or with other technical work-arounds, but sometimes four hands are simply better than two.

Image Editing

Today most pictures undergo some form of image editing. Every image stands to benefit from having one or two dust particles removed or the tonal values of the colors corrected. Food photography is no different because vibrancy conveys a large part of the appeal for many foods. Although eye-catching color is especially important for fruits and vegetables, it also matters for the bright white and cream tones in pudding and yogurt and the whole palette of brown tones in bread, baked goods, chocolate, and meat.

You can generally monitor the color values in RGB images adequately on a well-calibrated monitor. If your images are intended for offset printing and will eventually be converted into the CMYK color space, it's important to make some final adjustments by correcting the color.

To investigate the color of your images closely, use the pipette tool in your image editing software to compare the color values of your image against the reference colors in a color chart. As a final precaution, when subjects are especially dependent on precise colors, you can have a color proof created. This will allow you to double-check that your photographed loaf of bread is an enticing crispy brown, that your tomatoes are tomato red, and that your yogurt doesn't have a tint of blue.

▲ *Making sure tomatoes look tomato red. A color chart can be a big help to control color and find the correct CMYK color value if your images will be printed.*

Assembly Instructions

Do-It-Yourself Accessories

Even in large professional studios, photographers must do craft work to trim and crop special reflectors, modify light-shaping tools, paint backgrounds by hand, and build props. Improvisation is an essential part of handwork. On the following pages, I introduce a few do-it-yourself projects that can make your work with shoe-mount flashes easier. You can find many other similar tips in my book *Low Budget Shooting: Do It Yourself Solutions to Professional Photo Gear*.

Small Bracket for Multiple Flash Units

When the output from one flash unit isn't sufficient to illuminate your scene adequately, you can use special brackets that will enable you to attach two or three units on an umbrella soft box or a reflector umbrella. Building a bracket for this purpose is fairly simple and very inexpensive.

For materials, you will need three flash shoes with tripod sockets, two quarter-inch screws, and one quarter-inch knurled screw with male threads on one side and female threads on the other. You can find an aluminum rail with a 20 x 5 mm (0.8 x 0.2 in) cross-section in almost any hardware store. First saw the rail to a length of about 20 cm (about 8 in), then carefully file and sand the ends.

Now drill three holes using an 8 mm (0.3 in) drill bit, and countersink the two on the outside as you see in the image. The distance between the holes will depend on the width of the flash units you plan to use. You can easily figure out the necessary distance between the holes by lining up your three flashes next to one another and measuring the distance between the center contacts. At this point, you're more or less finished. The only question remaining is how to fire the flashes, and there is more than one suitable answer. If all three flashes have an integrated infrared sensor, there is an easy solution: they'll all automatically fire when the master flash discharges. All three flashes could also be attached to a three-way splitter with a single infrared or radio sensor. The splitter could, of course, be hooked up to a sync cable. You should be able to find splitters at well-stocked stores that carry photo equipment.

Holders for Styrofoam Reflectors

The fixing bracket for Styrofoam reflectors is made of a piece of aluminum rail and a knurl screw that has male threads on one side and female threads on the other, similar to the bracket for multiple flashes. Instead of drilling holes at either end of the rail for the flash mounts, however, you will drill holes to make tines for the bracket.

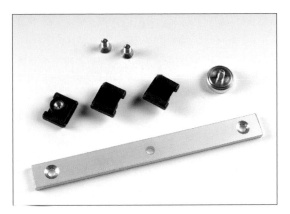

▲ Materials: Three flash units, one knurl screw, one aluminum rail, and three inch-long screws.

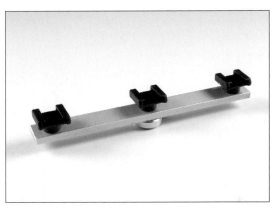

▲ The rail can hold up to three flash units.

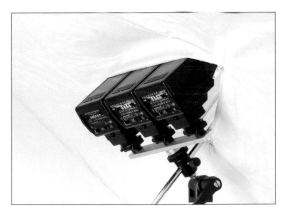

▲ The result is perfect for umbrella reflectors and umbrella soft boxes.

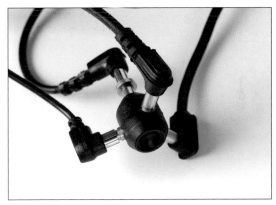

▲ You can control the flashes by using a sync cable and a three-way splitter.

The tines are actually large carpenter nails that you simply slide through the holes in the rail. When the holes are slightly too small for the diameter of the nails, you can use a hammer to tap them, and they should stay snugly in place. If the holes are too large, you can glue the nails in place with two-component adhesive. You will be able to attach the Styrofoam holder to a light stand with a tilt head or an unused camera tripod because it has a tripod socket. The only step that remains is to stick the Styrofoam in place on the nails.

A Small Honeycomb Filter

If you want to create precisely targeted light effects, but you don't want to invest in additional equipment, you can build a small honeycomb filter attachment out of simple materials. You'll need black cardboard, black straws, and superglue. This honeycomb filter consists of two separate parts: the honeycomb insert (made of the black straws bound together) and a cardboard tube (which mounts the honeycomb filter to the flash). This two-piece structure has nothing to do with the way the filter alters the light of the

Simply stick the Styrofoam plates onto the nails.

▲ You'll need black cardboard, black straws, a box cutter, and adhesive.

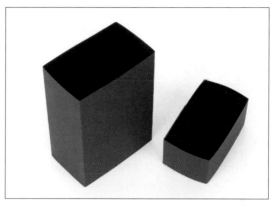

▲ The spot attachment is made of two parts: a tube for attaching the light-shaping tool to the flash unit and the honeycomb filter.

▲ The honeycomb attachment is filled with sections of black straws, which are fixed together with superglue.

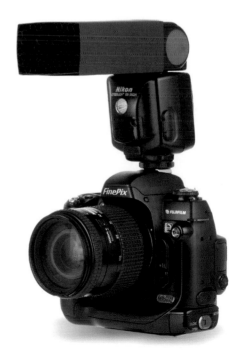

flash; it only makes the construction as simple as possible. It's much easier to work with straws, which will eventually become the honeycomb, when they are secured within an inner cardboard tube.

Let's get started with the smaller tube. To build the tube, you will need a piece of black cardboard or strong construction paper with a length of about 25 cm (9.8 in) and a width of around 1.5 cm (0.6 in). Measure the dimensions of your flash, and use these measurements to figure out the exact size needed for the piece of cardboard. You may want to score the lines where the cardboard should be folded. Glue the ends of the cardboard together so they overlap somewhat.

Now you need to fill up the newly constructed cardboard tube with segments of the straws that are trimmed to a length of 15 mm (0.6 in). After the straw segments are evenly spread out, secure them by adding a small drop of superglue onto the joints where the straws touch one another.

Wrap a rubber band around the straws to keep them from sliding around while the glue dries. The second tube binds the honeycomb filter to the reflector of the shoe-mount flash. The construction of this tube is the same as the other tube, but your measurements must be increased by 1 mm (0.04 in) so the honeycomb filter will fit within the larger tube. After

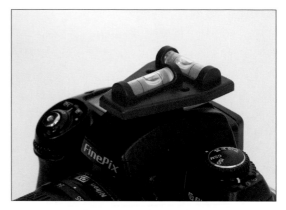

▲ *You can purchase inexpensive, small bubble levels at hardware stores.*

▲ *You can use the foot of an old accessory to easily attach the level to the camera's shoe mount.*

you've assembled the individual pieces, all that's left to do is put them together and attach the homemade light-shaping tool to the flash. After the filter is attached, you can add a few pieces of adhesive tape to secure it in place.

Bubble Levels for Your Camera

Sometimes it's important to have your camera perfectly level. This is quite simple to do if you equip your camera with a bubble level from a hardware store. To attach the bubble level to your camera, glue an accessory foot that will fit into the camera's shoe mount onto the backside of a bubble level. You can get an accessory foot that fits into your camera's shoe mount at a secondhand photography store or a flea market.

Infrared Triggers

With the infrared trigger described here, you will be able to trigger a remote flash without a mess of cables. The only hardware you'll need is a secondhand flash unit that you can buy inexpensively on an Internet auction or from the discount bin at a camera store. The power output of the flash is insignificant—even small flash units are fine for the purpose because short distances are used in a small studio photo shoot. For this reason flash units with a small

▲ *By using an old flash unit and the leftovers of black slide film, you can create a simple infrared trigger.*

guide number and small dimensions are ideal.

If you can find a flash with a reflector that can be pointed upward, similar to the one in my example, this improvised trigger will have another advantage over new ones. Some subjects, such as those with reflective metal surfaces, pose a problem for traditional infrared triggers because they reflect the small red light on the front of the master unit. This light has to be removed using an image editing program. By pointing the improvised trigger upward, however, you don't have to worry about this problem.

To block the spectrum of visible light as it leaves the flash, you will need to use two layers of unexposed

developed slide film that is completely black. Since slide film already has a certain rarity today, you'll need to pay a visit to the photo store for this, too.

When you have the film, trim it exactly to the dimensions of the flash unit's reflector and secure it over the reflector using one or two pieces of transparent tape. That's it—your infrared sensor is ready to go. Doubling the layers of slide film will permit only the infrared rays of light through. This signal is strong enough to be transmitted to a remote slave flash equipped with an infrared sensor and fire the flash. For safety reasons, you should check to see if the reflector gets too warm with the film taped to it. This normally isn't a problem since small flash units aren't capable of recharging and refiring very quickly, and the low guide number isn't capable of producing high temperatures. Using a powerful studio flash at full output as an infrared trigger, however, would not be safe; the heat could cause the film to fry, and both the flash and the photographer could sustain damage or injury. If you choose to build this infrared trigger or any of the other accessories described in this book, please understand that you do so at your own risk.

▲ *Plastic tubs can be a great substitute for photographing small objects when you don' t have a light tent.*

Plastic Tubs as Light Tents

Light tents can also be easily and inexpensively improvised. This setup works especially well for small objects that have glossy or reflective surfaces, such as flatware, watches, and other similar objects. The main piece of equipment is a white translucent plastic tub that you can find inexpensively at any store that sells household goods. Insert a sheet of white cardboard to function as the backdrop, and your light tent is ready to use. For larger objects you can set up the shot in your bathtub. Use indirect lighting by bouncing the flash off a piece of white cardboard. You'll be surprised with the results!

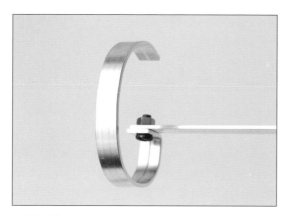

▲ *The thin aluminum strip can be bent by hand to accommodate larger or smaller watches.*

▲ *In imaging software after the shoot, you can easily remove the support rod and touch up the areas between the watch body and the wristband.*

Watch Holders

You won't always have a special watch holder handy that you can use in a photo shoot. You can, however, devise a simple solution by building one out of a narrow piece of aluminum, which you can purchase at regular hardware stores. The piece used in the illustration has a cross-section of 11.5 x 2 mm (0.5 x 0.08 in). Using a hacksaw, saw one 16 cm (6.3 in) piece for the ring and another 20 to 25 cm (7.9 to 9.8 in) piece to function as a lateral support.

After you file the rough ends of the metal down, drill a hole that's 5 to 6 mm (0.20 to 0.24 in) near one of the ends of the lateral support. This hole is where a screw will later attach the two pieces. Fold back one end of the 16 cm (6.3 in) piece about 1.5 cm (0.6 in), and then bend the rest of the rail into an oval with a height of 7 cm (2.8 in) and a width of 3.5 cm (1.4 in). The easiest way to do this is to hammer the strips with a rubber mallet over a rounded piece of wood.

To finish the watch holder, screw the two pieces together. Because of the lateral attachment, you don't have to attach the holder to the background of the scene, so you can light the background separately. If you don't want the mount to show up in your im-

▲ *A metal plate with a tripod mount is bolted to the underside of a wooden plate.*

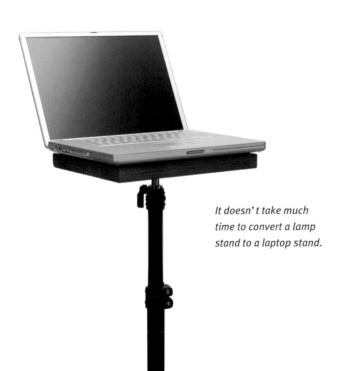

It doesn't take much time to convert a lamp stand to a laptop stand.

age, you can loosen the screw and rotate the support so it points backward and is hidden behind the face of the watch.

If you choose to do this, though, you won't be able to clasp the watchband because the support rod will be in the way. One work-around for this problem is using double-sided tape to affix the watch body to the watch stand. If you want to stage the watch so it is standing freely on the surface of the photo table, you can separate the ring part of the watch holder and use a hot glue gun or two strong magnets to hold it upright.

Laptop Mount for Light Stands

If you intend to use your laptop to control your camera, you will most likely need a cable connection between the two. This poses a problem: where should you put your computer? End tables are generally too low, so you end up working hunched over or on your knees. If the camera is positioned relatively high on a tripod, the connecting cables can also be too short. One way to address this problem is to make a laptop table attachment for a light stand. This requires, of course, that you have a light stand to spare for the purpose.

The attachment consists of a stable board, a metal plate with a tripod socket, and a couple of strips of

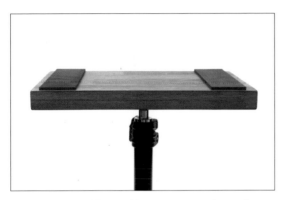

▲ *Broad strips of foam rubber prevent your laptop from sliding off.*

▲ *An elastic band provides an additional safety belt.*

foam rubber. Look in your hardware store's scrap box to find an inexpensive piece of wood that is roughly the same size as your laptop base. If the board needs to be trimmed down to size, the hardware store staff should be able to help you.

Next you'll need a metal plate with a quarter-inch tripod socket and a couple of holes for wood screws that will join the metal plate and the board. Drill the holes and attach the tripod socket, then screw the metal plate to the center of the board's underside. Now you can fasten the table surface to the light stand, thanks to the tripod socket.

To prevent your laptop from sliding off the table, attach a couple strips of foam rubber to the top of the board. You can also wrap a thick elastic band, available in sewing stores, around both your laptop and the table for added security.

Now you can easily adjust the table and laptop to a comfortable height. Of course, the stand can also be used as an adjustable side table for the actual production setup. In addition, if you place a tripod ball head between the board and the stand, you can use the board as a rotating table for taking 360-degree shots of all kinds of objects.

Beyond These Pages

To conclude, I'd like to send you on your way with a few Internet addresses. This is a collection of informational sites, blogs, help resources, and reference materials for equipment discussed in this book. This list is not exhaustive, but will provide you with some helpful information.

The authors of these websites are responsible for their own content.

www.lowbudgetshooting.de
My own Internet site, where you can find information about my books, my other projects, and me. This site is written in German.

www.rockynook.com
The international publisher of the English editions of my books and a wide variety of other books on digital photography.

www.flash2softbox.com/index-en.php
Information about the flash2softbox adapter that I helped develop.

www.strobist.com
The English-language site for all strobists (photographers who use shoe-mount flash units for lighting).

www.kevinkertz.com
LightingSetup.psd, a Photoshop file for noncommercial use that helps with planning the positioning of elements in a photo shoot.

www.krolop-gerst.com/blog
Thorough blog covering many topics relating to shoe-mount and system flash technology. It includes tutorials, videos, and more, and it is mostly oriented to portrait and fashion photography.

Information/Sales: Radio and Infrared Triggers

http://www.bowensusa.com/index.php/pulsar-transceiver.html	Bowens Pulsar Radio Transceiver
www.paulcbuff.com/cybersync.php	AlienBees CyberSync
www.pocketwizard.com	PocketWizards
http://www.profoto.com/us/products/air/air-sync	Air Sync
www.radiopopper.com	RadioPopper

Other Books by Cyrill Harnischmacher

Low Budget Shooting:
Do It Yourself Solutions to Professional Photo Gear
© Cyrill Harnischmacher 2007
ISBN 978-1-933952-10-9

Starting the job of working with light is no inexpensive affair. The mounting costs of professional lighting equipment can quickly sap anyone's budget. Soft boxes, light tents, photo tables, strip lights, and diffusers—the prohibitive costs of these tools prevent amateur photographers from trying them out and experimenting with them to learn what these light-shaping tools can do. It poses a few questions for photographers: Could I build this equipment myself? What tools and materials would I need? How could I put together a cost-effective tabletop studio? This book answers all those questions.

The German edition of this book received the Foto-buch-award of the German Booksellers Association in 2005.

Closeup Shooting:
A Guide to Closeup, Tabletop, and Macro Photography
© Cyrill Harnischmacher 2007
ISBN 978-1-933952-09-3

Macro photography is one of the most fascinating areas of photography—every step forward is a step into a new world. This world lies right before our eyes, but it is so small and fleeting that we often can't perceive it without the help of the right equipment.
Macro photography, in other words, is a journey into the unknown with constant surprises and a seemingly limitless supply of subjects.
The German edition of this book received the Foto-buch-award of the German Booksellers Association in 2006/2007.

Digital Infrared Photography

© Cyrill Harnischmacher 2008

ISBN 978-1-933952-35-2

Snow-covered landscapes in midsummer, mystical mood lighting, moonlight effects, fascinating color distortions—discover the possibilities of recording the world with invisible light. In this book you'll read about the fundamentals and theory of infrared photography, cameras and lenses designed for this purpose, infrared filters, various exposure techniques, special infrared cameras, modified digital cameras, image optimization in the digital darkroom, color effects resulting from channel exchange and partial toning, and the proper methods for black-and-white conversions.

The German edition of this book received the Fotobuch-award of the German Booksellers Association in 2009.

The Wild Side of Photography

© dpunkt.verlag GmbH 2010

ISBN 978-1-933952-51-2

Geared toward the adventurous photographer, *The Wild Side of Photography* provides a rich source of ideas and inspiration for fun projects ranging from clever to unconventional.

Editor/designer Cyrill Harnischmacher brought together 20 international authors and their unique projects to produce this intriguing book. Each project is presented with easy to understand instructional text, background info about the author and the project, and beautiful color images to illustrate what can be accomplished and how you can do it too.